GRAPHIC FACILITATION
AND ART THERAPY

Dear
President Meyer –
All best wishes to
you and to Fielding
That
Maxine Borowsky Junge

GRAPHIC FACILITATION AND ART THERAPY

Imagery and Metaphor in Organizational Development

By

MICHELLE WINKEL

and

MAXINE BOROWSKY JUNGE

With a Foreword by

Charles N. Seashore, Ph.D.

CHARLES C THOMAS • PUBLISHER, LTD.
Springfield • Illinois • U.S.A.

Published and Distributed Throughout the World by

CHARLES C THOMAS • PUBLISHER, LTD.
2600 South First Street
Springfield, Illinois 62704

ISBN 978-0-398-08738-8 (paper)
ISBN 978-0-398-08739-5 (ebook)

Library of Congress Catalog Card Number: 2011046598

With THOMAS BOOKS *careful attention is given to all details of manufacturing
and design. It is the Publisher's desire to present books that are satisfactory as to their
physical qualities and artistic possibilities and appropriate for their particular use.*
THOMAS BOOKS *will be true to those laws of quality that assure a good name
and good will.*

Printed in the United States of America
MM-R-3

Library of Congress Cataloging-in-Publication Data

Winkel, Michelle.
 Graphic facilitation and art therapy : imagery and metaphor in orga-
nizational development / by Michelle Winkel and Maxine Borowsky
Junge; with a foreword by Charles N. Seashore.
 p. cm.
 Includes bibliographical references.
 ISBN 978-0-398-08738-8 (pbk.) -- ISBN 978-0-398-08739-5 (ebook)
 1. Art therapy. I. June, Maxine Borowsky. II. Title.

RC489.A7W56 2012
616.89'1656–dc23
 2011046598

*To Lauren, for her encouragement and
unending patience with all of my creative pursuits.*
M.W.

*In memory of Will McWhinney, mentor, teacher, and
thinker who influenced my path in a thousand different
ways and continues to mentor me long after his death.*
M.B.J.

FOREWORD

Graphic Facilitation is a powerful way to add a third dimension to the content and interaction of our deliberations and meetings. We are all used to making notes on flip charts and filling walls with those flip charts. But a picture is worth a thousand words and Graphic Facilitation is the art form that adds the depth, the reflection, and even the interpretation of a trained observer to the world of process. My experience is that it is somewhat magical, remarkably beautiful, and definitely catalytic to my own participation in group experiences. In the hands of the skilled practitioner, it is an on-line, up-to-date extraction of the essence of what is arising from the dynamics of the group. It is like being a part of a book being written with illustrations that capture the vivid, the important, and the charm of what is occurring. *Graphic Facilitation and Art Therapy* is an articulation of what goes into the creation of this art form with some wonderful examples of graphics that are a part of selected case studies.

The visual image is a powerful addition to the two kinds of reflection critical and essential to learning from experience. The emerging graphic allows for reflections *in* the process, as well as reflections *on* the process after the end of a meaningful unit of work or the end of the task at hand. The product evolving on the wall over time is dependent on the inner process of the artist. First is the capacity to perceive what is going on at both the individual and the group level. Second is the power to hold onto those perceptions long enough to develop a meaningful context that captures those perceptions and separates the critical few from the trivial many. Third, and this is where the magic comes in, the Graphic Facilitator imagines and visualizes a clear way to translate the essences of the experience into visual forms that include in creative ways key words, concepts, and phrases that are memorable. Only then can the chalk, markers, or crayons fill the wall

chart with graphics that have accuracy, charm, and compelling use of color.

The magic of imagery brings life to our words. It is the transformation that is often more vivid that speakers themselves can articulate. It is the functional equivalent of pulling rabbits out of participants' hats. Though clearly the magic imagery is generated from the Graphic Facilitator, it is immediately associated with the intentions and connections grounded in the actual expressions used by speakers. As with all forms of magic, it brings forth the wonderment, appreciation, and excitement of those who view the mural, including those who were not even in the room at the time of the event. A look at the graphics included with the case studies in this book should verify this last point. It is likely that the illustrator, if asked, would say that they are simply putting down what they "heard"–a magical thought if there ever was one!! Even more magical is the process by which the images of the illustrator invite the viewer to release his or her own images.

Personally, visual imagery and the work of the Graphic Facilitator are a relief from the world of words which often are our best defended tools of disclosure. The picture can represent what isn't quite being said as well as what is being directly spoken. It also serves as a stimulus for the participant to develop his or her own visualizations of what has been going on. It is not necessary for the graphic artist to speak out to describe his or her selective perceptions as those perceptions simply speak for themselves. As the process develops, it is possible for alert participants to track what is going on by integrating their own perceptions and those of the graphic artist. Although this sounds like a complexity, in practice, it is actually a rather simple catalyst for the thought processes of the observant participant. I suppose there are lousy graphic artists but in my own experience, I have been impressed with the high quality and significant contributions of a wide variety of artists who have worked with groups where I was a participant.

There are lots of reasons for the well informed organizational practitioner and the art therapist to own this book. Understanding the history, the process and the potential contributions of Graphic Facilitation to our world of work in groups and organizations is perhaps the most important reason. But I personally found that the book stimulated my own thinking about the graphic artist that is latent and eager to get out into the open air. It is a long way from making doo-

dles to doing gorgeous and memorable wall murals, but it is possible to enjoy the expansion of the creative visualization capacities that lie within each of us.

What these two remarkable authors have done is to take their world of visual imagery and provide the words and cases that are fundamental to this spectacular addition to our world of meetings and interactions.

Charles N. Seashore, Ph.D.
Malcolm Knowles Professor of Adult Learning
Fielding Graduate University
Santa Barbara, California
And
Emeritus Member
NTL (National Training Labs)
Arlington, Virginia

In addition to Fielding Graduate University where he has been a faculty member for 20 years, and NTL where he was Board Chairman and a member for 47 years, Charles N. Seashore taught for 15 years in the Johns Hopkins Fellows Program in the Management of Change and is a founding member of the American University/NTL Masters Program in Organizational Development. He is an organizational consultant to national and international organizations, specializing in medical settings. Dr. Seashore's group dynamics expertise is disguised within a disarming and humorous personality. In 2004, he received the Lifetime Achievement Award from Organizational Development Network. Seashore is the author of numerous articles about applied behavioral science and *What Did You Say: The Art of Giving and Receiving Feedback* (with Gerald W. Weinberg and Edith Whitfield Seashore).

ACKNOWLEDGMENTS

My gratitude starts with my first art therapy professors and mentors, Maxine Junge and Debra Linesch. They taught me well and inspired me to practice art therapy boldly. This gave me permission to take the art therapy craft into organizations years later. Both women have followed my journey and supported my work till today. Max's enthusiasm resulted in proposing we write this book together, and without her, it wouldn't have happened. I am indebted to Max for her consistent focus and dedication during the process, as well as her support over the years.

Thanks to my colleague and friend Florence Landau and her family for kickstarting me into this field years ago.

As I have moved from the art therapy arena into organizational work, I have had a few key colleagues, in particular Bert Zethof and Delaney Tosh of the Surge Strategies Group. Bert has encouraged the use of Graphic Facilitation in our work together and provided a new insight for me into its value in our consulting work. He has also been a mentor through various challenging assignments, teaching me how to strike a balance between bolstering clients and pushing them at the same time.

Early clients and mentors, Yoland Trevino and Leticia Alejandrez, are Graphic Facilitation enthusiasts, and fabulous community activists and leaders whose work and support I will always value.

Many thanks go to Rose Vasta for her ongoing wisdom and encouragement. I am thankful to Connie Carter for her practical and emotional support and Xiole Fiestra for lending her photoshop technical skills. Thanks also to Lisa Arora, a colleague in visual practice, for her encouragement.

I am grateful to our publisher, Michael Thomas of Charles C Thomas Publisher for his confidence in this book.

I would like to express my deep gratitude to my sister, Tonya Winton, and her family and to my parents for their loving and patient tolerance. I'm an artist and not always easy to please. And, of course, to my partner Lauren Nackman, I am forever indebted for her endless support, from talking over my brilliant and not-so-brilliant ideas while hiking, to advising, editing, and cheerleading while writing this book.

<div align="right">M. W.</div>

My first thanks go to Charlie Seashore for his Foreword. I don't know anyone who could understand and appreciate the magic of Graphic Facilitation like Charlie.

Searching for a doctoral program, pretty much by accident, I discovered the Human and Organizational Development School at the Fielding Institute. There I found a whole new area to feel at home in, and to suit the interdisciplinary maverick in me. At Fielding, I found a group of people who supported and appreciated the work I wanted to do in a way that I had never encountered before, nor have I since. They deserve my thanks—for this book—and they are "my people" for many of the books I have written before this. Some of their names are Jody Veroff, Charlie Seashore, Ora Agmon, Don Bushnell, Anna di Stefano, Libby Douvan, Will McWhinney, Michael Esnard and Susan Taira. Many other names—both students and faculty (which are often the same at Fielding)—belong here as well. Without their encouragement and help, I could not have begun to understand the nature of this journey.

Always making himself available in the midst of his busy life as Professor of Anthropology at SUNY, my son Benjamin has provided me with the technical support necessary to finish this book. In our process together through many books, I taught Ben that I didn't want to learn *how* to do it; I simply wanted his help to do what I wanted to do. He gracefully acquiesced, which must have been hard for him since he is a natural teacher. When I told him I thought this book was my last, he said: "I've heard that before." Since I listen carefully to what Ben says, I say here "who knows?" Benjamin also took my picture for "About the Author."

I want to thank my publisher, Michael Thomas of Charles C Thomas, who has published my last four books. He has been always supportive, helpful, and interested—a rather unusual stance for a pub-

lisher, I think. I treasure our e-mail relationship and discussions over the years, but especially I value his appreciation for me as a writer.

Claire Slagle is my Editor. She once told me she thought I must have been asleep when I wrote a certain chapter. When I read it over, I decided she was right. Claire's careful eye and her tactful manner make working with her a pleasure. Trevor Ollech is the cover designer par excellence. His imagination and creativity have been both surprising and encouraging. His understanding and ability to quickly make the changes I suggest is nothing short of amazing.

Michelle Winkel, my collaborator on this book deserves my thanks. Collaboration of any kind, can be sticky. Michelle's brave adventure into the organizational world enabled me to come in contact with a part of myself that I have enjoyed bringing to the forefront. The five impressive case studies are Michelle's work and show an art therapist at the top of her game, creatively expanding her knowledge and skills into the organizational world. Besides, she has generously put up with me and my contributions—not always welcome, I am sure.

Betsy, my Havanese dog, sat next to me or on my lap for most of this book. She has been a loving collaborator.

M. B. J.

CONTENTS

Note: Color versions of these illustrations can be viewed on the accompanying CD-ROM.

FIGURES

Works by Maxine Borowsky Junge

A History of Art Therapy in the United States
(With Paige Asawa)

Creative Realities, the Search for Meanings

Architects of Art Therapy, Memoirs and Life Stories
(With Harriet Wadeson)

Mourning, Memory and Life Itself, Essays by an Art Therapist

The Modern History of Art Therapy in the United States

Graphic Facilitation and Art Therapy,
Imagery and Metaphor in Organizational Development

GRAPHIC FACILITATION
AND ART THERAPY

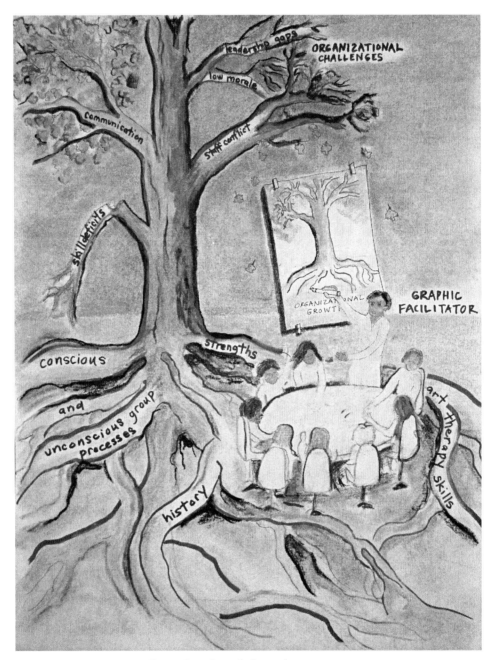

Figure I-1. Growth from the roots up.

Chapter I

INTRODUCTION AND BACKGROUND

Graphic Facilitation is an innovative and wholly new application of art therapy theory and techniques to groups and organizations. It offers the art therapist entry into the business community and is a non-clinical arena where an art therapist's natural skills and expertise can find renewed validation. Graphic Facilitation is *a process* in which a trained consultant, using color, symbols, imagery, and metaphor in murals, interprets and documents something as short as a keynote address or as long as an entire conference.

Michelle Winkel writes: This book was born in Max's living room when I spent a few days with her while cycling around her idyllic Whidbey Island in Washington State. Over glasses of wine, we talked about our respective work and shared thoughts about how the field of art therapy has grown over the years since I was her student in the early 1990s at Loyola Marymount University in Los Angeles.

As I described the evolution of my own identity as an art therapist, now primarily working in the corporate and government sector, Max, a systems thinker, recalled her own organizational development and education work during her substantive career. Her doctoral work was in organization systems. Although she consulted to organizations using art and maintained an organizational consulting practice for many years, she had never written about this work. Always an advocate for advancing art therapy into new areas, she remarked how exciting it would be to write about the graphics work with organizations. I agreed. I remembered how tough it had been to train myself as a Graphic Facilitator. There just wasn't anything written that would give me some ground under my feet. What I did read didn't approach the depths of the work I was trying to do: Using art and visual metaphors

to move groups through organizational conflicts. I felt as the early pioneer art therapist must have felt (and many after, as well)–isolated, alone and as if I were inventing a whole new geography with few established landmarks to point the way.

Art therapist Maxine Borowsky Junge, co-author of this book, received her doctorate in "Human and Organizational Systems," from Fielding Graduate University. She established an organizational consulting practice in 1985 and often used art experiences as part of her practice. With the encouragement of her mentor, Will McWhinney, Junge informally used the mural process described herein. Co-author and art therapist Michelle Winkel created her own "Graphic Facilitation" process in Los Angeles and Sacramento, California and in Canada; she used it to work with a variety of different kinds of groups, from a few individuals to one or two thousand. (Some are described in the Case Studies of this book.) Winkel also created a firm, "Unfolding Solutions," in which she uses art to consult to groups, businesses, and organizations.

Traditionally, language and the written word have been used to document organizational and group occurrences–such as the ubiquitous "minutes of the meeting." But words, no matter how carefully crafted, represent a rather distant abstraction of the real event. Words are indicators of the person writing them and the record often becomes a photograph more of the reporter than of what is reported. This selection process is seldom acknowledged. Verbal documentation, ostensibly objective, is consciously and unconsciously subjective and is the creation of the writer. What is chosen for inclusion, how it is framed, and what is left out are all choices. Graphic Facilitation, while including words, is frankly subjective and interpretive and usually includes words but within the context of visual imagery and metaphor.

A very few art therapists have used their expertise to further organizational and business aims,(Ault, 1983, 1986; Ault, Barlow, Junge & Moon, 1988; Stoll, 1998, 1999a, 1999b; E. Speert, personal communication, 2010; Turner & Clark-Schock, 1990; Clark-Schock, personal communication, 2010; Bosky, 1992). Ault (1988) states:

Businesses or other institutions can, and do, become ill. . . . These ills are often caused not by market problems, but by failures of human

relationships working within systems. . . . But what if you look at these structures as family systems and use family art therapy methods? (Ault et al., 1988, p. 13 quoted in Feen-Calligan, 2008)

Few art therapists have presented papers at conferences or published in the organizational/business areas and none have used Graphic Facilitation. (For further description of art therapists and their forays into business, see Chapter VIII.) Graphic Facilitation as conceived by Winkel and Junge is a new approach for art therapists and is likely to provide an exciting expansion for the future of the art therapy profession.

Winkel writes:

I started training as an art therapist in Los Angeles in 1993. As with all new trainees, I was both eager and terrified to practice some of my textbook knowledge in the real world. Each week, I came to my clinical supervision with client artwork in hand, brimming with insights from the sessions. My supervisor encouraged me to make art in response to my thoughts and feelings. I created art from my gut, not always knowing or understanding its meaning or intent. Novice art therapists, many already self-identified artists when we began art therapy training, were unfamiliar with this process, or at least did not have a name for it. Later, I would call this process of art-making to interpret and document a therapy session or organization session *"Graphic Facilitation."*

Graphic Facilitation is decidedly *not* art therapy. Organizational work and the organization profession are based primarily in systems thinking and limits, and parameters and intentions differ from therapy of any kind. Nonetheless, that an organization, like an individual or family *has a psychology* which is expressed through behavioral dynamics and meaning making is a shared assumption which makes Graphic Facilitation an obvious arena for a trained and skilled art therapist.

Written by two art therapists, this book is for art therapists who would like to develop and learn to use art therapy applications for business and organizational sectors. The book is also intended for "the other side"–business coaches, human resource managers, organizational management consultants and facilitators who want to enrich their practice with the exceptional nuances that working with art can bring to the business world. We predict that uses of art and business

will provide new excitement and experiences as the boundaries of the art therapy and organizational development professions intertwine and expand.

Chapter II

WHAT IS GRAPHIC FACILITATION
AND WHY DOES IT WORK?

INTRODUCTION

Many of us get stuck in our heads barely aware that our minds chatter about everything and nothing. Stress, anxiety, and irritation mask layers of feeling and help the individual avoid the present moment. For most, this impacts enjoyment of life and limits creative potential. In the America of today, the ability to focus is arguably a national problem. Overused and indicative of the issue is the widespread psychopathological diagnosis of "Attention Deficit and Hyperactivity Disorder" (ADHD). This diagnosis remains a common finding for many pupils–particularly boys–in elementary education. It is claimed that early diagnosis will lead to early help and is, therefore, an advantage. But the unfortunate reality may well be that the large numbers of children said to have ADHD could reflect a largely unrecognized cultural and public health epidemic or, on the other hand, there may be cultural and gender bias and unrealistic expectations involved. The ubiquitous use of psychiatric medication to "treat" this issue implies potentially unknown future impact and ramifications for adolescents and adults.

Increasingly, we are an overstimulated culture overwhelmed by mountains of information. Considered a highly desirable skill, the concept of "multi-tasking" promotes a lack of focus on any one thing and can cause mental health and societal issues such as traffic accidents, workplace violence, and bullying on school campuses. Current culture encourages overintellectualization and mental health disciplines em-

phasize cognitive therapies to shape behaviors. Health insurance companies want the quickest fix possible to reduce costs. Surface externals are desired, while deeper depths of human personality and group and individual behavior are largely overlooked or eschewed altogether. The cult of celebrity and surface physical beauty are rampant and tantalizing; the internet, while putting information back in the hands of individuals, blurs the boundary between truth and lies while issues surrounding the difference between personal privacy and public space have a major and troubling prevalence. The social computer networking movement promotes a form of communication tending toward brevity, surface interaction, and a lack of depth. TV as a cultural signifier–in particular reality shows and the video game industry–promotes violence and a striking dumbing-down of the American population. The "advances" of technology have caused a new series of major practical and ethical challenges and questions which will take many years to resolve, if even possible. Many people feel bombarded with "noise" which often signifies little and renders language itself meaningless.

What roles do the artist and the art therapist play in current cultural trends and how can art help people focus on what matters? We will attempt to answer these questions in the following chapters as we describe case studies that reflect the power of the visual. There is also a CD-ROM at the back of this book, containing figures *in color* and "Graphic Facilitation in Action," a short film showing Michelle Winkel creating a mural in an organizational meeting.

An artist often creates with an intended final product in mind: a painting, a drawing, a piece of pottery. The viewer can be present within the artist's imagination and considered in some way throughout the process. "Who am I making this for? What will the viewer see or value in this piece?" the artist might ask themself before and during creative production. In an art therapy session, the client is invited by the art therapist to respond to and project their internal world into the created artwork; the art therapist acts as witness.

Responsive artwork gives the art therapist a structure, through which to listen, digest, and interpret verbal and nonverbal content. This same basic principle–responsive visual interpretation to conscious and unconscious content–shapes the evolving field of Graphic Facilitation. A few visual practitioners incorporate images and words into their

work, but they describe it differently than Graphic Facilitation; they often add word diagrams or icons to help elaborate on the content of the material. (See Chapter VIII for further definition of these differences.) Increasingly, all organizational facilitators are savvy and sensitive to visual learners in a group and want to capture their attention. A difference from Graphic Facilitators is that most are not interested in or adequately trained to address the subconscious and unspoken material which emerges through group process. For example, graphic recorders usually respond to the overtly stated requests of their clients exclusively, such as drawing the conference or event content–as a court reporter might document a court proceeding. They are unable to "hear" the equally important story underneath the manifest, some or all of which may be unconscious material.

Like making art within the safely-held space created by an art therapist, Graphic Facilitation moves beyond language. It quiets chatter and noise, and helps the group find and explore nuggets of honesty essential to meaning-making and change.

An organizational event can be viewed as a creative, living act as it unfolds in front of the participants and in front of the Graphic Facilitator in the meeting room. It holds within it the seeds of change and action which can lead to a desirable future for the organization. Language alone cannot tap these multiple aspects of an event. How the experience is interpreted and made visible by the Graphic Facilitator creates *a reality which is permanent over time and manifests group meaning.* A visual map is provided by the Graphic Facilitator, pointing both to an historical past and current reality. This roadmap illuminates potential cultural and organizational change.

Graphic Facilitation offers a focal point for a group that language alone can not provide. It can be containing for visual learners and provides a structure in which innovative thought can flourish. The group comes into the meeting room anticipating doing something; they are talking with peers, managers, and colleagues about some kind of problem. They plan to follow an agenda focusing on the problem and how to fix it. There are variations in felt comfort and trust. The Graphic Facilitation process weaves a visual element into the mix, making discussions less a matter of habit and more an expanded imagery of meaning. It has the power to shift the group out of comfortable complaining and into a realm of possibilities.

An art therapist's skills and training teaches how to *translate emotional material into imagery to enable in-depth discussion*. In an organization, the interchange back and forth between the group's words and the drawings on the wall creates a rich and engrossing dialogical dynamic. The Graphic Facilitator reflects voices and metaphors back to the group, validating their experience and preventing them from forgetting the vital nuggets that have floated up to the surface. Group participants are able to see a reflection of their process on the mural which typically generates confidence to go deeper. The created mural affirms a direction in a manner that simple conversation may not. It pushes boundaries by encouraging exploration.

HOW DOES A GRAPHIC FACILITATOR WORK?

A "Graphic Facilitator (sometimes called "Visual Planner," "Strategic Illustrator," or "Graphic Recorder") works real-time on site with a group of any size. They listen intently to the meeting or event content while it is happening and interpret, reflect, and document the process by drawing it in a mural. Simple paper and art materials are used. Sometimes a white board or large paper on tables are workable as well, depending on the size of the group and room layout. The Graphic Facilitator typically prepares for the meeting by mounting large sheets of paper on the wall. When the meeting begins, the Graphic Facilitator listens for symbols and metaphors expressed by the group and translates them into images using markers and chalk pastels. The murals are usually 4 feet high by 6 to 12 feet wide, although they can be wider or narrower as needed. In the mural, the Graphic Facilitator synthesizes ideas, processes and key themes of the group and organizes complex information into meaningful visual structures. A Graphic Facilitator states:

> Group members see me drawing . . . it shifts them into something more meaningful than chatter; they are more focused. It is back and forth, between me and the group. I am witness, facilitator, and guide to the group process. I am quiet and a bit physically distant. I may not talk much. I want the group to unfold in its own way; I talk at certain points; I may describe what I have heard when I am drawing. When I show empathy for what the group is expressing, it is likely to

move into new directions. This usually flows naturally if I am present and attuned to the needs and interactions of the group.

WHAT IS THE VALUE OF GRAPHIC FACILITATION?

The process helps ideas emerge and engages the attention of "visual learners" (approximately 65% of people).[1] Businesses, government entities, and nonprofit organizations share the need to build creative energy and to communicate well both within their own boardrooms and hallways and to their customers. They must also be able to work together in successful teams to continually improve and change their approach to the product or service. In today's financially-stressed business environment, it is companies that innovate and break new ground who lead their markets.

Not unlike an art therapist working to help a family or individual, organizations grapple with the stunning effects of *change,* the *emotional content* of human beings relating and working together, and the immense *challenges of necessary, continuous learning.* Without guiding structures, such as those created by Graphic Facilitation, discussions can flounder, attention lost, and key ideas not brought forward when needed.

The fields of organizational development and human resources coaching have proposed that it is the complex human interactions and the ability of people to adapt and work together that either hinder an organization or enable it to soar beyond its competitors. Like art therapists, Graphic Facilitators provide reflection and guidance so that the work can be truly seen and understood in a concrete visual fashion— an important step toward implementing creative innovation and change.

1. All groups include visual learners who may disengage or entirely shut down during meetings that are all talk. The creative potential and the time and money spent for disengaged visual learners may be largely wasted.

GRAPHIC FACILITATION AND THE IMPORTANCE OF CURRENT FINANCIAL CHALLENGES IN ORGANIZATIONS

In past years, the United States has endured the most crippling recession since The Great Depression of the 1930s. Collapsing financial markets have led to reorganization and uncertainty. Millions are unemployed and have been for a long time; many have lost their homes. "The American Dream" seems an impossible fantasy. Many businesses recognize that times such as these can provide new opportunities to devise innovative strategies or gain a foothold by marketing something original. If there is little to lose, there may be more room for creativity. Organizational innovation can become an essential strategy for achieving a competitive advantage. Organizations that may have struggled unsuccessfully for years to resolve challenges using conventional organizational development strategies are often suddenly able to shift to a more positive perspective when they employ Graphic Facilitation.

The field of Graphic Facilitation is emerging. Like the pioneers of art therapy, early graphic recorders are training themselves and creating their craft along the way. Several were organizational development consultants in San Francisco during the dot.com boom who wanted to find more effective, client-centered tools. David Sibbet, a key pioneer in this field, established The Grove Consultants International (see Chapter VIII). Through trial and error and much experimentation, some organizational consultants with artistic flair added visual practices to their facilitation. To our knowledge none were trained as art therapists.

A NEW ARENA FOR ART THERAPISTS

In their formal education, art therapists are not typically educated in business processes and practices. Despite this, they have the capacity to add significant value to organizations because of their skills in psychology and art. In fact, they are often better qualified to do Graphic Facilitation than those trained in Human Resources, business management or administration and organizational development because of art therapists' understanding of concepts of group dynamics, psychology and the psychology of organizations, systems and groups

(cf. *Morgan's Images of Organization,* 1996 and Lakoff & Johnson's *Metaphors We Live By,* 1980).

GRAPHIC FACILITATION AND THE
NAUMBURG-KRAMER CONTINUUM IN ART THERAPY

Margaret Naumburg is known as the mother of art therapy. Her theory promotes an art *psychotherapy* practice in which the art therapist is a psychotherapist with particular skills who uses art to further the client's healing. The aesthetic nature of the art product is not important. According to Naumburg, it is the therapy client, not the therapist who interprets his or her art as both explore it together. Edith Kramer claims that the art therapist is *not* a psychotherapist and should not strive to be one. For Kramer, an art therapist is similar to a psychologically-informed art teacher. Her theory rests on the person's experience of the creative process itself. Kramer believes that it is the transformation of socially unacceptable impulses through art that is helpful; this process she calls *sublimation.*[2] According to Naumburg, the art therapist is a special kind of psychotherapist. Their role is to help the client verbally explore the unconscious manifested visually in art. Kramer maintains a different path for the art therapist, one in which the creative process of art-making by the client is emphasized (Junge, 2010).

In our daily lives, we are bombarded by images. For the most part, we are passive receptors of these images, not *co*-creators; we are rarely asked to be co-creators. Television requires passivity and most computer imagery requires no input but the occasional clicking of the mouse. Despite our world being filled with images, benign and otherwise, that we have not created, we are usually not consciously aware of the meanings of these. They become simply part of the "noise" of everyday life. Graphic Facilitation offers group participants the opportunity to be co-creators in a visually stimulating and evocative process. The Graphic Facilitator is the "artist." They start the drawing and give it a framework. Sometimes they invite group members to draw on or

2. Sublimation was a Freudian defense mechanism. Later, Freud's daughter, Anna, and the ego psychologists redefined sublimation not as a defense but as a normal unconscious ego process (Junge, 2010).

contribute to the mural. As the Graphic Facilitator works, group participants watch their ideas unfold in the imagery, which can be very exciting. The imagery describes what they spoke about and sometimes what they avoided speaking about:

> I'm interpreting organizational dynamics by virtue of what I select to draw. My internal process has been maturing over the years–this is the really tricky part of my role. I can't get caught up in documenting flip chart-style, all of the content the group discusses. I don't feel that adds much value, or at least it is not my focus or my talent. It is the nuances of deciding what content to ignore and what to capture that makes the mural flow. I am a vessel: I listen carefully and empathically to the information I hear from the group; I process it, reflect on it and finally, translate it into imagery. I reflect back what has been happening in the room, words as well as floating emotional content.

Unlike art therapy where the client drives the process through art making, *the Graphic Facilitator is the artist.* They create the documenting mural and most importantly *choose* what to interpret in the mural; the creative process for group participants is not one of personal art making. Rather, it is the Graphic Facilitator whose sensitivity and skills are essential, but are not unlike the sensitivity and skills of a good art therapist. Often overlooked by group members as they focus on the business of the meeting, the Graphic Facilitator can grab the varieties of content in the room and choose to portray them or not. Art makes a richer and deeper experience.

The created mural can be thrilling to group members; it opens to them a world of aesthetic visual meaning typically not "seen" through words alone. The creative artistry of the mural becomes an additional and exceptional group member who is willing to confront with honesty, to explore with directness, to illustrate what is said and to reveal what is unspoken:

> As I mature as a Graphic Facilitator, I get bolder about making interpretations of group dynamics in the murals. I dare to choose metaphors that may be confrontive. I think about how to convey tensions or conflicts. If I am wrong, the group will tell me. I ask them to tell me. If I am right, I push the group to move their conversations into new directions.

In that the mural representation by a Graphic Facilitator imagistically portrays the group or organization's dynamics for all to see, feel, explore, and move forward from, Graphic Facilitation and the role of the Graphic Facilitator are closer to Naumburg's theoretical definitions than Kramer's. The mural is documentation and a trigger for forward movement and change at the same time. The Graphic Facilitator *publically* enacts a deeply creative and usually private process: On a two-dimensional surface, using colors, metaphors, symbols, and words, the Graphic Facilitator creates an intriguing world of feelings not usually seen with the "naked eye." Like the art psychotherapist, the Graphic Facilitator creates an ambience of safety and structure for group participants. They also try to create enthusiasm, curiosity, and a sense of play resonating within the room and invite people to participate.

> I speak at the beginning of the day about the Graphic Facilitation process and what group members can expect to see. I describe why it will add value to their day, deepen their experience and promote inclusivity. I welcome jokes about how I choose to draw something. Sometimes the most important work is in the silent spaces. Murals give groups permission to leave the world of petty irritations with managers and co-workers and make space for newness. I create an environment of curiosity.

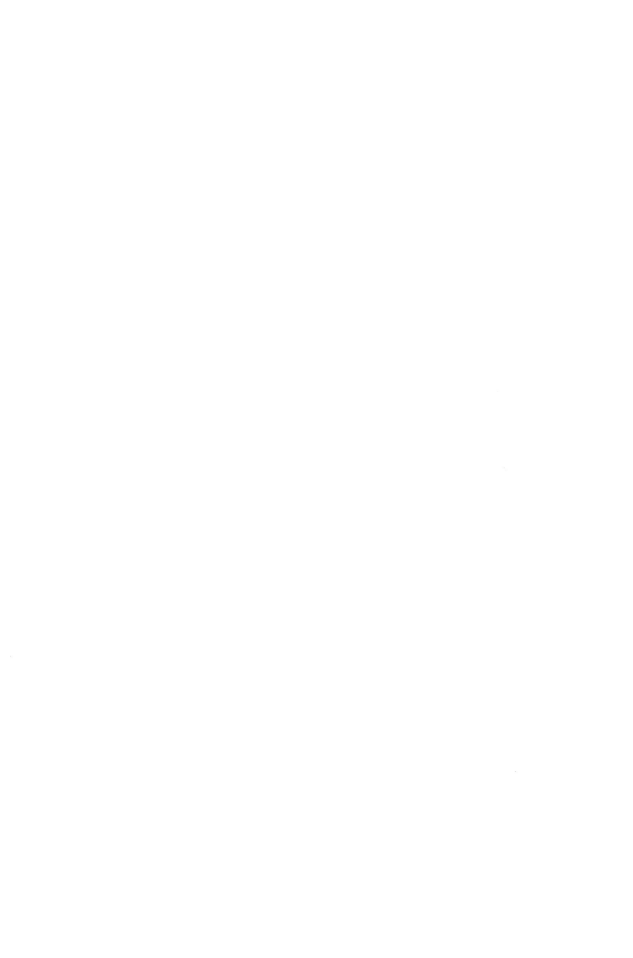

Chapter III

CASE STUDY NO. 1.
THE ELEPHANT IN THE ROOM

INTRODUCTION[1]

In Case Study No. 1, I describe a one-day retreat with a Human Resources Department within a university. There were 50 participants. Of these, 44 were employees and six were management. I drew two murals during the retreat. In the first, I illustrated major issues of the department; the "Elephant in the Room" was the central visual metaphor. In the second mural, I expressed participants' desires to connect interpersonally and the structural and functional difficulties prohibiting such interaction. In Figure III-1, left, an elephant is shown walking on a path with the question "How do we connect?" A word balloon defines what the elephant is thinking. It says "Opportunities!? What are they? Let's assess them."

CLIENT

The client is the Human Resources Department of a large, public university. This Human Resources (HR) Department is made up of two smaller divisions: one is called the "Human Resources Division" and the other is "Occupational, Health, Safety and Employment Division" (OHSE). The HR division within the HR Department has about a dozen more employees than the OHSE department.

1. Case studies I-V are the work of Michelle Winkel, therefore the personal pronoun "I" is used.

17

Figure III-1. The elephant in the room/opportunities. (Color version of this illustration can be viewed on the accompanying CD-ROM.)

REQUEST

I received a request to graphically document a retreat for the Department of Human Resources. The internal organizational development consultant on staff[2] together with the Vice President and Department Manager of Human Resources, planned to host a "World Café as it is sometimes called. "World Café" is a facilitation format or strategy often used in groups to "awaken and engage collective intelligence through conversations that matter" (http://www.theworldcafe .com/retrieved June 15, 2011). In this approach, larger groups are broken into self-selected smaller discussion groups in order to enhance interaction and engagement. Typically, themes are assigned to tables. The small group participant can have a proactive role in choosing what theme interests them most, maximizing the likelihood that they will stay present and interested.

In retreats of this size and purpose, the facilitator typically designs the format in advance. She or he works with the client to set goals, identify priorities, and design activities to align with the event's purpose. With this client, the goal of the retreat was to explore department culture, interpersonal dynamics, employee integration, and clarity of strategic direction.

FIRST MEETING WITH CLIENT

My goal in an introductory meeting is to gain information about the organization and to understand the purpose of the coming event. The first meeting is like an intake with a new client in art therapy: I want to get a sense of the client's perception of their challenges and as much contextual background as possible. Questions asked are: What have they tried already to solve the problem? What do they hope to gain from the event? How will they know they've succeeded? Who will be participating? Do the participants know why they are coming? How do they perceive the challenges? Have these issues been openly discussed before? I describe the Graphic Facilitation process and

2. An "internal organizational consultant" is employed by the organization. An "external consultant" is one who is contracted by the organization to accomplish a certain task, but is not employed by the organization. A Graphic Consultant is typically an external consultant.

answer any questions from the client. The Letter of Agreement/
Contract between the Client and the Graphic Facilitator/Consultant is
discussed and completed (Appendix A is an example of a contract).
There may be contracts specific to the organization that need to be
signed, as well.

Present at this first meeting were the internal Organization Dev-
elopment Consultant (OD), the Human Resources (HR) Manager,
and the Graphic Facilitator. The OD consultant, although relatively
new, was insightful about organizational issues currently at play. The
HR Manager had many years of experience working with employees.
Wanting to add a bit of creativity to the day, the two had heard about
Graphic Facilitation and were intrigued. An external consultant was
hired to facilitate the retreat. He was not present at this meeting. Man-
agement would participate in the retreat as equals with staff. Back-
ground and general organizational departmental structure were dis-
cussed. The agenda for the retreat had been left to the external con-
sultant facilitator. (I would meet with him later.)

Previously, a cross-department survey had been carried out and it
was given to me. From it, I had the sense that *integration between divi-
sions* was an issue. By the end of the retreat, leadership from the HR
Department wanted participants to gain an understanding of the roles
of other divisions in Human Resources and how the department as a
whole contributed to the university's overall vision.

To prepare, I looked at the room for the retreat, decided on a
smooth flat wall that was large enough for the murals, checked for ade-
quate lighting and discussed where the group facilitator might be situ-
ated in relation to the group.

PREPARATORY MEETING WITH EXTERNAL
CONSULTANT/GROUP FACILITATOR

A few days later, I had a telephone meeting with the external con-
sultant/facilitator. He had been contracted to present an overview of
the previously conducted survey and generally take the lead in facili-
tating the retreat. During the conference call, the facilitator explained
survey results to me and described the retreat agenda that he had
developed. In turn, I described the Graphic Facilitation process. The
consultant/facilitator seemed receptive to my illustration process; he

...suggested changes which were intended to improve the flow of the creative process into the agenda.

EVENT

... as they come in the room and connect ... ice conveners. My aim is to portray a ...

... selected their own seats at round tables. ... the agenda and oriented people to the ... e university started the day with his ... introduced myself and my role and invited participants to enter into the process throughout the day.

A Goal to Enhance Collaboration

Typically, I encourage group members to watch my drawing evolve and to contribute to the mural by coming up and adding words or pictures on post-its during breaks which I incorporate later. I ask them to tell me when they see things I draw that they like or they disagree with; this enhances collaboration. Sometimes, I suggest we have pauses during the meeting for the group to reflect on the murals and give feedback. When this happens, the lead facilitator will pass the floor to me and I describe to the group what I am drawing. I might ask the group questions I have had brewing. I tell them that I hope they will feel comfortable approaching me or the mural and that they will find it dynamic and stimulating.

I Begin Drawing and Encounter Expected Resistance

While the President gave his keynote, I drew the title of the retreat, the date, names of the two facilitators and themes from the keynote address on the mural paper (Figure III-2, top and bottom).

As I began, I noticed that retreat participants were not very engaged; this is common. Group members are often resistant and take some time to dive in. They need to relax and settle. Participants may come with significant workplace frustration which can be focused on

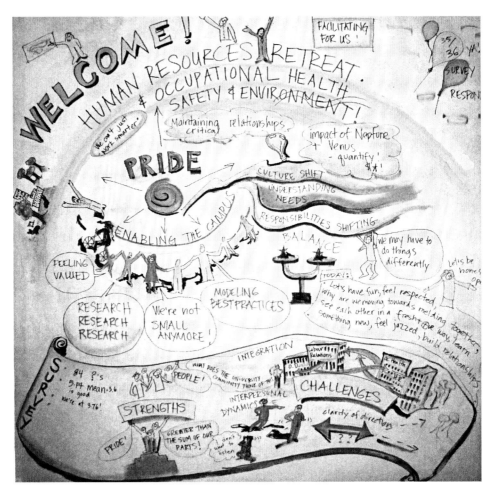

Figure III-2. Connecting and the difficulties of connecting. (Color version of this illustration can be viewed on the accompanying CD-ROM.)

management or colleagues. They may be distrustful that a short retreat can make any difference and are reluctant to be vulnerable only to be later disappointed. Working together across hierarchical levels of the organization can be threatening. Will I be punished for being honest? Dare I speak my mind? Do I have anything of value to say?

I sensed an expected hesitation in the room and registered it as something to pay attention to as I tracked changes throughout the day. I continued drawing themes from the keynote address: pride, balance, and building relationships among others (Figure III-2, center). After the keynote speech, the facilitator presented the results of the Human

Resources survey to the group. I noticed that the material did not seem to invigorate the group, perhaps because it didn't hold any surprises for them.

I kept this first mural light in content as I warmed up to the dynamics of the group and they warmed up to the event. I used bright colored markers and chalk to illustrate a positive picture of people coming together to understand and connect with each other.

World Café Format Introduced

The facilitator explained the World Café format: Each of five tables was labeled with a theme related to the day's goals: *Building on Strengths, Clarity of Direction, Integration, Pride, and Meeting Challenges.* Participants were invited to circulate to the table with the theme that interested them. They were told to sit and dialogue with whomever else was at the table. A "host" was assigned to each table to take notes. Twenty minutes were allotted for a segment so that participants had the opportunity to go to several tables and engage with a few themes.

I Draw "Etiquette" Guidelines on the Mural

I drew the following "etiquette" guidelines on the mural: *Focus on what matters, contribute your thinking, speak your mind and your heart, listen to understand, link and connect ideas, listen together for insights and deeper questions, play, doodle, have fun!* (Figure III-2, lower center right). The lead facilitator suggested to the participants that these guidelines were important ways to keep engagement high in the World Café format. He oriented them to the stack of blank flipchart paper and a few markers of different colors in the center of each table, and encouraged them to doodle to enhance their conversations.

The group laughed nervously and made a joke about not being able to draw well. I quipped back with a few encouraging comments. As art therapists know, this is an essential dialogue at the beginning in which the participant (client) expresses their fear of the art processes. As with clients, this conversation also covertly displays participants' (probably unconscious) general resistance which they have expressed through their focus on the artmaking. The Graphic Facilitator (as does the art therapist) encourages them and assures that any art will be fine. This is an extraordinarily important dialogue which builds trust and

relationship. Without this very basic conversation, in Graphic Facilitation (or in art therapy), it is difficult for the process to go forward successfully.

<div align="center">**"Butterflying"**</div>

When large groups break into small groups–like the five theme tables of this World Café–and several conversations are happening at once, I take a sketchbook and "butterfly" around the room drawing emerging themes I hear. Usually, I can capture themes from each table. My focus is where conversation generates the most energy. Energy can look like laughing, arguing, or several people talking at once. It can also be a quiet unexpressive group; my assumption with this kind of group is that people have many things to say but are too afraid to speak and are "sitting on" their feelings. To repress feelings takes a lot of energy.

On this day, my sketchbook drawings concerned *themes of disconnection* as symbolized by two parallel pathways which never intersect and with a pile of rocks on each path. The rocks symbolized obstacles getting in the way of connection. Another theme in my sketchbook was *lack of groundedness, belonging,* and *place,* symbolized by drawings of figures floating in the sky. This metaphor was transposed when I later drew on the mural. It became the foundation wall (Figure III-1, center)–a symbol that grounds the floating figures and provides containment.

Creating a Solid Foundation: A Common Theme Emerges

On this day, I was struck by similar verbal metaphors emerging at different tables. (Commonality is not unusual, because participants often have similar feelings about their workplace situation.) I wanted to highlight the common metaphors so I drew on the mural the theme that I heard around the room: *Creating a solid foundation* (Figure III-1, center).

At one table, the group was talking about a need for stronger direction from leadership, greater clarity of vision, and a more explicit sense of purpose. They seemed frustrated and somewhat angry. A woman who had previously been quiet stated that she felt unwelcomed by staff in another unit when she walked through the building hallway. Her

face was sad and her voice was low. This was the first time I had seen her lean forward in her chair; it was a good sign that she was definitely now engaging with her peers about her feelings. Others listened, then expressed similar feelings of alienation and lack of connection to the other team. Two group members were new employees. They wanted more direction from their managers regarding their role–how to do some aspects of their jobs, and how to fit into the bigger picture of the department. They spoke of their confusion and of not knowing who was responsible for what in the department. The discussion grew heated as group members discovered mutual frustrations within the safety of the group. An "Orientation Checklist" was suggested. Wanting to underscore this positive action plan from the group, I drew the checklist on the mural (Figure III-1, upper right).

Simultaneously, another group talked about the lack of a common space to gather. This meant people could not exchange ideas with each other. Wanting to feel included and know what other staff were working on, they felt this kind of interaction could lead to a sense of communal pride in their work.

Many in the group expressed anger about a generalized lack of interpersonal kindness and communication, interpreted from closed office doors, the lack of eye contact, and basic courtesies. This metaphor was a common one in the groups and obviously held meaning for all, so I decided to adopt it for the mural. I drew a foundation wall with strong bricks to signify a solid base structure titled "The Gathering Place"(see Figure III-1, center).

A Theme of Integration Emerges

A common theme I experienced while circulating through the room was the strong sense of tension and conflict between the two divisions of the Human Resources Department. Participants from one division perceived they were like younger siblings or foster children; they claimed they didn't get the respect garnered by their "larger" and "more important" colleagues. These reactions were partially based on the fact that people in the department worked with closed office doors and didn't talk about their work or lives which created a feeling of exclusion. One participant suggested a "soft eyes" policy, stating it was a way to approach colleagues from a place of intentional loving kindness rather than a place of negativity or paranoia. In my view, the for-

mat gave participants the opportunity to address tough issues which resulted in a more confident, optimistic atmosphere.

I represented these thoughts and feelings about this particular World Café in my sketchbook, but then chose to go directly to the mural on the wall as the 20-minute whistle blew instructing participants to change tables. I wanted to document what I had heard while it was fresh in my mind, and I took advantage of the scurry in the room as everyone stood up to move to another table. I drew these issues under the subtitle "Interpersonal Dynamics" on the far right of the mural (Figure III-1, far right center).

Throughout the World Café, I moved back and forth between the small tables and the wall where the mural hung. This was a bit of a dance for me which I have learned to negotiate over the years as I come to understand what works best. I take advantage of the sometimes frenzied energy of the room, and try to capture important concepts in my sketchbook, or I draw directly on the mural if the timing is right and going to the mural wall will not break the flow. Often there are at least two small groups at tables having a discussion right near the mural wall, so I am able to draw directly on the mural rather than in my sketchbook.

I drew each of the five themes of the World Café in ovals around the edges of the mural (Figure III-1, perimeter). *Building on Strengths* (Figure III-1, lower center), portrays figures with cartoon balloons saying key comments I heard from the small groups, including "handling tough situations, we do it well," "ya [sic], let's go together," "shared responsibility and personal accountability," and "learning from each other." The drawn oval shape has a subheading: "Do people know their own strengths? Recognize and leverage."

After several rounds of conversations, the small group portion of the World Café was closed. The facilitator brought the larger group together and gave the microphone one at a time to each table's "host." Taking turns, they summarized their group's discussion and pointed out the specific themes to the larger group. This helped me capture even more of the material from the small groups. Then, after the five group hosts had spoken, I described what I was drawing on the mural and asked them to give feedback about the metaphors I had chosen to draw so far.

The larger group debriefed with the facilitator about the process while I continued drawing and consolidating sketches from the smaller groups. At the same time, I was listening to see what new content there might be for me to document. Their main focus of conversation was on clarity of direction and the concept I called "The Gathering Place," described below.

DESCRIPTION AND INTERPRETATION OF THE MURALS

Metaphors in General

I drew a vision of an ideal work environment (Figure III-1). In this mural, I illustrated one table looking toward management as if the employees were looking to leadership for structure and guidance, entitled "Clarity of Direction" (Figure III-1 upper right). Next, I drew a foundational wall and within it the joint common space the two divisions hoped to create in their buildings and hallways. This "Gathering Place" shows staff drinking coffee together, sitting in comfortable chairs in a safe environment and, perhaps most importantly, making eye contact. Within the Gathering Place there is a "project wall" envisioned by participants to showcase what others were doing in the department. Underneath the first three ovals, I drew a large elephant called *"How do we connect?"* The elephant is walking along a path called "Getting rid of the great divide."

Meanings of the Elephant Metaphor

This Human Resources Department was essential to the effectiveness of hundreds of university employees. Despite the overarching morale of the department, which seemed disgruntled and isolated at the time of the retreat, I felt the staff was smart and loyal. It needed somehow to achieve a better spirit of confidence, collegiality, and collaboration in order to play its role effectively. Participants were not bold enough to talk about their difficulties in front of management. But from experience, I knew that management would need to be instrumental in making changes for the group and therefore must hear directly what their employees were feeling. My drawings could push this to the forefront and illustrate the felt, but largely unspoken "elephant in the room."

Collaborating with Staff Participants on the Mural

I spoke to the group about my impressions. I guided them through the mural and asked if this felt like an honest depiction of their department. They expressed interest in the parallels of the simultaneous conversations. The murals and the resultant dialogue gave the group permission to talk more openly together.

One staff participant called out that the title of the retreat I had written across the top of the first mural should say "Human Resources *and Occupational Health, Safety and Environment Retreat,*" which was the other unit in the department. I quickly added this to the title. With this important inclusion, I noticed that OHSE staff seemed to relax into their chairs: They had elevated their position as a department simply by speaking out and were now appropriately represented in the title of the mural.

In the mural along the road, I had drawn a pile of rocks with a caution flag. As we attempted to address the elephant challenge, some participants brought up historical events and blaming, harmful to moving the process forward. With the drawing of the pile of rocks, I intended to warn that focusing on the past can be an obstacle (Figure III-1, lower right). Near the path, I drew several people working together. This represented shared responsibility and personal accountability. My discussion with participants had evoked this theme along with a desire to have opportunities for more collaboration and connection.

COMMENTS

Most organizations are hierarchical. Typically, it is management that schedules a retreat and has intended goals for it. But management is also likely to be aware that the opportunity presented by a retreat can encourage employees to be more open about their satisfactions and dissatisfactions. In a retreat, management may hear information that they are not aware of and that they will have to decide to act on or not. Merely holding a retreat such as this invites employee participants to be collaborative members of the team and models that it is *everybody together* who can create change.[3]

3. The TV reality show "Undercover Boss" in which a company CEO works undercover with the "rank and file" is a good example. The CEO's experience often results in a series of changes within the organization.

However, it is primarily management that must institute change for employees and which holds responsibility for the effectiveness and direction of the organization no matter how much collaboration with employees is invited. One can hope for an open management with a lack of defensiveness and a willingness to listen and move forward. Unfortunately, often this is not the case and management may remain rigid and controlling. It is typical that the expectations of employee participants for a more nurturing workplace ascend during the relative openness of the retreat. But the realities and difficulties of change and the time it takes means that expectations may need to be managed with patience and sensitivity by staff and by the organization.

My interpretation of the themes and issues felt by the group came first as a drawing and later in words as I described the drawing to the group. Like an art therapist, I tested my interpretation by asking participants if it felt right. My questioning prompted conversation within the large group and brought into the open many hidden concerns.

Dialogue illuminated positives among the group which otherwise might have remained unspoken. Stimulated by the murals and by my interpretations, participants openly discussed important issues in the presence of management. As is often the case in business and organizations, this intervention proved critical for change. Like family art therapy, although the family may present with an "identified patient," it is not that person alone who creates or carries the family's problem; rather, the problems are systemic within the family dynamics. Like an art therapist treating a family, within an organization, the Graphic Facilitator must work *systemically* to promote change.

The elephant metaphor was my creative insight which gave a substantive yet faintly humorous cast to the drawing. It was drawn in a three-dimensional style to indicate a substantial presence in the workplace world. The elephant is the major element of the bottom half of the mural and is bigger than anything else. The elephant metaphor proved important and complex in that elephants are large, have long memories, and are impossible to ignore. The elephant in the mural does not get mired down in its history but keeps moving forward. It is my guess that retreat participants will remember the visual image of the elephant long after they have forgotten specific verbal themes and issues of the retreat time.

For this retreat, art introduced a *gentle and pleasurable way to directly confront* inherent organizational difficulties. The aesthetic element contains nuances to stimulate imagination, which often can enable participants to peel away their habitual defenses. At first, the visual impact of the mural is a *witness* to the group's process and progress. Later, it becomes a collaborator in the change process.

Chapter IV

CASE STUDY NO. 2.
THE DILEMMA OF OUTSOURCING

INTRODUCTION

In Case Study No. 2, I describe a half-day meeting with a small group of government employees. The group was composed of five staff members and their manager. My colleague and I co-facilitated the meeting at the clients' office. During this meeting, I drew two murals. The murals helped clarify and focus discussions regarding a typical project lifecycle in the department. These murals delineated staff roles and communication patterns between staff in and across departments, and with their clients.

In the first mural (Figure IV-1 "Project Contact Points"), I illustrated a jogging track to describe the typical trajectory of a project in this government agency. The second mural became an extension of the first (Figure IV-2 "Ideal Service Delivery Path"). It portrayed the ideal process for projects, according to the group participants on this day. I continued with the metaphor of a track weaving through the landscape.

CLIENT

My client was a department within a large government agency. The department was made up of about seven staff members who work directly with external clients. I will refer to them as *account managers*. This government agency builds and manages facilities such as public

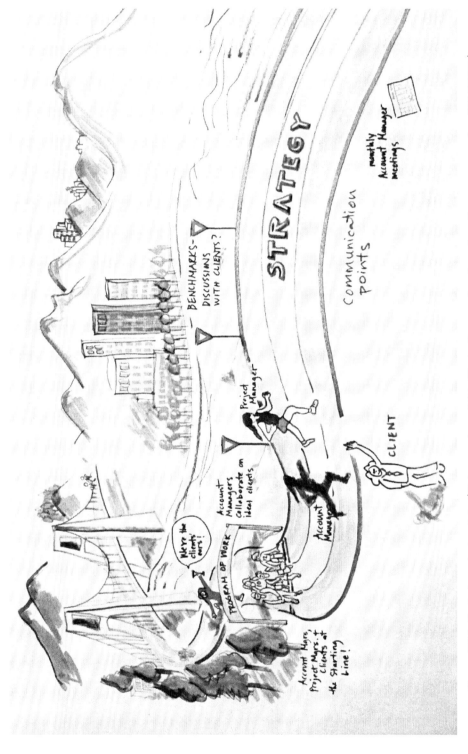

Figure IV-1. Project contact points. (Color version of this illustration can be viewed on the accompanying CD-ROM.)

buildings and bridges for other government agencies across the country. Account managers play a key customer-facing role in most projects that this agency undertakes.

BACKGROUND AND PREVIOUS WORK WITH CLIENT

While the Graphic Facilitator is often employed to create documentation for an event, in this case, the graphic facilitation for this meeting was one part of an ongoing relationship with the organization, where I and my colleague were engaged in a broader management consulting project. This required some flexibility on my part to provide a variety of services and support to help the organization reach their transformational goal, including the graphic facilitation described here. This was the first time I had engaged in using visual processes with this client.

In many ways, this consultant's role is not unlike the art therapist who must learn to "speak" the language–sometimes many languages–of the client in order to effectively enter into their existential universe and, when the art is introduced, must teach the client about its uses. I worked with these account managers as a management consultant (without art) for several months preceding the meeting. I helped them and other staff with various assignments. It was the agency's charge to implement a new business model that became the focus of the Graphic Facilitation meeting presented here.

This government agency had recently developed a new business management model: its goal was to become a more "modern organization." To achieve this goal, it needed to be able to compete with private sector companies to whom their clients could take their projects. Clients had already complained that the government agency was slow and unresponsive to requests and that their projects were rarely done on time because of the many antiquated, bureaucratic processes slowing down final project delivery. Concurrently, the agency faced a staffing shortage. They had many unfilled vacancies, with more than half of their workforce eligible to retire within five years. A new business model was urgently needed which would address the staffing crisis and the client dissatisfaction.

A key feature of the new initiative for the organization would be *outsourcing* some of its services. Outsourcing has become a common

practice because it provides organizations with the flexibility to hire quickly for short periods of time, at less expense and with less effort. During difficult budget times, staff employees sit idle, while still receiving health and other benefits associated with employee status and cost the company money. Outsourcing consultants may cost more per hour but are ultimately less expensive for companies.

My client planned to outsource parcels of work from about a dozen of their departments to private sector consultants. They had prepared a schedule with target goals for each department. Previously, I had worked in the Project Management Department in a management consulting role, so I knew the steep challenges to be faced. These project managers were saddled with the difficult mandate to outsource up to 75 percent of their work. They reacted with frustration, fear, anger, anticipation, enthusiasm, and pessimism. A significant number of staff were disgruntled, long-term employees nearing retirement, who were being asked to radically change their long-held ways of working.

The account managers I now consulted with had worked closely with the project managers, and often listened to complaints from clients about project managers' performance. This presented a delicate communications triangle, which we would explore during the Event.

REQUEST

In addition to the Graphic Facilitator, an organization sometimes hires an external facilitator/consultant to run an event and, in this case as mentioned, to work with me as Graphic Facilitator to accomplish certain preliminary tasks. For this project, my client was the *Accounts Management Department.* The director of the department requested that my colleague and I first conduct an analysis of *the need* for better client engagement, or relations. A *Needs Analysis* is a systematic process to gain an overview of strengths and weaknesses in the department's communication with its clients. This is much like the assessment usually leading to diagnosis and treatment planning in the first few sessions of art therapy.

For the *Needs Analysis,* we would interview all account managers, several clients, and some key project managers. Our plan was to create a *communications strategy based on the results of the Needs Analysis.*

These account managers dealt with clients on a daily basis and knew them well. In the meeting I describe here, the specific goal was to explore how they perceived *their clients would accept outsourcing.*

To prepare for the half-day meeting that forms this case study, I asked staff about concerns their clients might have about outsourcing plans. I wondered why staff seemed so worried; was it simply a concern with the change in their own role, or worry about the client, or both? As I found out, there had been many negative rumors floating around–especially from worried clients wondering what would become of their projects under the new outsourcing model.

Clients' concerns were understandable; they did not yet know how outsourcing would impact project costs, timelines or quality. Because previous communications about this transition had been unclear and inconsistent, some clients were reluctant to allow outsourcing of their projects at all and declared that they might not hire the department if outsourcing began. Rumors of all kinds were pervasive and staff morale was declining. It was imperative that the Project Management Department and the Account Management Department meet together. They would consider priorities, client needs, and communications as well as be prepared to evaluate their outsourcing protocol to make changes if necessary. It was imperative that clients be consulted about their concerns, and have their questions answered in clear and consistent ways.

PREPARATORY MEETING WITH CLIENT

My colleague and I met with the Director of the account managers a week before the Event. We had met with him on a couple of other occasions related to an earlier project, so we knew him and he knew us. He was quite enthusiastic about his work and committed to the idea of the new outsourcing initiative. With our help, he wanted to bring some realistic, practical tools to his staff. He had been an account manager himself and was painfully familiar with the difficulties of addressing angry clients every day which was a common feature of a staff role. The Director showed insight into the benefits of collaborating with and communicating thoroughly with disgruntled clients and strongly felt that customers should be viewed as part of the team.

My colleague and I co-facilitated this meeting. We were familiar with each other's facilitation style and worked easily together, picking up on each other's concepts, moving the dialogue back and forth in a loose flow. I used Graphic Facilitation throughout the meeting.

EVENT

The half-day event was held in an attractive trapezoidal-shaped room with two glass walls and two standard walls, one of which had large white boards with protruding metal frames and the other, a projector screen mounted on them. The glass walls divided us from other internal halls and were etched with a privacy landscape from the floor to about seven feet up. Because of the etched glass and lack of open wall space, I decided that rather than using paper for murals, I would use the white boards already in the room. Colors would be limited. Because I wouldn't be able to use the chalk pastels, I knew the final artwork would be less rich without the variety of colors and media. I only had six white-board colors as opposed to two dozen regular marker colors. The large boardroom table had a dozen chairs around it so we sat facing each other in a circle, with my back to the wall containing the white boards.

Five account managers, all women, came in punctually. I could tell they were a sharp bunch—funny, warm, engaging, and articulate. This group was a shift from the introverted and reticent project managers and engineers I'd been working with in previous meetings. The account managers began to joke as they came in, about events going on in the office and even about their clients' ongoing complaints. I noticed that they didn't stop joking when their Director came in. It was obvious they were a solid team that valued each other, trusted their boss, and trusted each other. However, their jokes and humor would prove to be a cover-up for extraordinarily difficult fears underneath. Despite their formal suits, dresses, and heels, they were casual with body language. We reviewed the agenda for the meeting which we had emailed to them a few days prior.[1]

1. Please note: An AGENDA for the meeting had been developed by the two consultants and was emailed to the participants PREVIOUS TO THE EVENT. These are professional necessities which indicate a level of understanding, organization and caring by the facilitator.

I Begin Drawing and Learn that Humor Covers Anxiety

After introductions, and a brief discussion about the background of the new business model, the group began to talk about *client perceptions* and *fears about outsourcing*. To my surprise, this discussion proved very stressful and anxiety-provoking for these account managers. Something was clearly occurring which I couldn't yet understand. I observed them raising their voices, becoming frustrated and agitated as they talked about their concerns for their clients.

Next, the cause of these account managers' anxiety became clear as they revealed an important and common fear underlying the pervasive humor: *they were terribly worried that the outsourcing initiative was really a subversive way for the company to get rid of their jobs and them.* They expressed concerns that fearful project managers were taking out their frustrations in damaging ways that would drive clients away and, in turn, their jobs would be lost. These account managers had significant contact with clients and staff in many departments, and had a most accurate assessment of organizational and client morale. Having opened Pandora's Box, the anxiety in the room escalated. I quietly stood up and began to draw.

Drawing Creates Breathing Space and Lowers Anxiety

My drawing created a visual segue which interrupted the urgency of staff anxiety and brought a few moments of calm into the room. I didn't give a verbal explanation to the group about the Graphic Facilitation process except to say, "let's try it and see how it goes!" Participants seemed curious about how the drawing would unfold and most were able to shift the conversation and attend to what I was drawing.

One of the most extroverted account managers, Marie, piped up when I drew a figure on the mural and said, "Well, if that's me, I wonder where my martini is?" I played along and drew the figure drinking a martini. Here, I used the opportunity for humor and joking to create "breathing space" in the room: I laughed and asked if anyone else wanted to be drawn holding a martini glass (Figure IV-1, center-left).

Everyone chuckled and the energy in the room shifted. As I might in an art therapy session, I used humor, relationship, and the visual medium to connect with my clients and push them to look at things

from a different perspective. My co-facilitator picked up on the space this shift afforded; he summarized staff's feelings of anxiety and concern, and opened up the next agenda item, "project contact points." Because of the art process, he was able to move on.

Account Managers' Views in the Drawing

Based on my prior work with project managers, I had formulated a rough idea about how typical projects unfolded in the department and wanted to understand the account managers' views and check out my assumptions. I knew the Graphic Facilitation would be an engaging way to document this understanding. To start, I drew a simple landscape with a path because I knew that this kind of image would be flexible enough to accommodate whatever evolved from the discussion. I then drew a mountain range with snow-capped peaks on the horizon behind a body of water. I added some buildings to the skyline. I drew a bridge in the upper left corner, with a path winding from the mountains in the distance. This metaphor indicates that the beginning of the path is far away, thus acknowledging that the department had been delivering projects for decades and had a very long history. The beginning of the path isn't visible: The meaning here was that most of these account managers were mid-career people with many years' experience; but despite their experience, they had not been around since the organization's inception nor knew much about its beginnings. Often they didn't know why things were done the way they were done. Many of the protocols that were current thorns in their sides long predated their employment. I drew some cyclists near the beginning of the path—for fun, and because this town was known for cycling. With my drawing of cyclists, I wanted to lighten the mood and bring air and pleasant breathing space into the room through visual means.

The group was asked to describe their role in the trajectory of a project's lifecycle, when they talked to clients, and how they interacted with project managers. I hypothesized that if this could really be understood, I might propose communication strategies with clients to capitalize on current contact points. From an organizational development viewpoint, I didn't want to waste time fixing what wasn't broken, but rather work on strengths.

The Group Tells Me I Am Wrong

I quickly learned that my assumptions were wrong. The group explained that, in fact, they didn't know much about the entire process of individual projects. Principally, their role was to sit down with the client to review and discuss their "plan of work" once per year. The "plan of work" was the *total group of projects* and not the individual project the client had hired the agency for. The intention was to *track business volume*, not trouble-shoot an individual project. Account managers do this only once per year. Each account manager had a portfolio of clients that she had developed long-term relationships with.

I represented this new information on the mural by drawing a starting-line banner over the path on the middle-left. Then I drew a jogging track emerging from the path—with many players, or "joggers" participating—to symbolize the project trajectory. At least two of the women in the group were actually runners and had completed marathons, so the jogging track image seemed right. I also felt that most projects in this agency were pressured by time, scope, and budget, and that there was a beginning, middle, and end to all projects, like the track.

Upon reflection, a jogging track implies a competition or race, which had some pros and cons as a metaphor for this group. Runners compete against each other, which is not an ideal metaphor because I wanted an image that would represent cooperation rather than competition. But I was aware of the underlying spirit of competitiveness among some staff in the departments, and probably tapped into that subconsciously in choosing this metaphor.

Next, I drew a group of joggers in different colored outfits under the starting line banner to represent the key organizational players we were concerned with (Figure IV-2, middle left). For clarification on the mural, I labelled them "account managers," "project managers," and "clients." Farther along the track, at about mid-point, I drew two figures jogging close to each other; one figure was dark, like a shadow behind the figure in the lead. I was *interpreting* visually what I *was hearing* in relation to project managers. I said, "So, you are in the lead and the project managers are like your shadow?" The group quickly reacted to this question and began to discuss it. "No, I think we are the shadow" they said. "Aren't we?" "Who is the shadow?" The shadow

drawing stimulated questions and provoked insights in an interactive dialogue: "Is the client the shadow? Is the client the leader? Where does the client fit in on the track at all?" they asked. The group decided the *client belonged on the sidelines,* so I drew their conception of the client as a large figure below the track in the middle. I was simultaneously trying to understand what really happened during a project, and depict it for the group while encouraging them to go deeper in conversation. I wanted them to question their own organizational processes and reflect on what worked and what didn't work.

My co-facilitator asked about the contact points between clients and account managers: How and when do account managers interact with clients? How, when, and to whom do clients communicate problems? While this dialogue was going on, I drew triangular "yield" signposts evenly spaced along the upper sideline of the jogging track to signal benchmarks (Figure IV-1, center). The metaphor implied a slowing down along the track to enable careful stock-taking of the project. We knew that account managers were required to sign-off on projects when they reached intervals of 33 percent, 66 percent, and 99 percent completion for quality assurance, but an obvious problem was that clients were rarely involved in this process.

Understanding Client Engagement Protocol

There was no way a new client engagement strategy could be proposed without accurately understanding and assessing the current model. But, it had become clear that what, apparently, was going to be a simple task of understanding the current model was tremendously complicated. I wanted to understand the client engagement protocol; the group said there weren't formal, set opportunities for communication between clients and employees except at the end of each project. When a project closes, staff complete a "lessons learned" report to summarize what went well and what did not. This report was viewed by many as a *missed opportunity* because it was *only the account manager* who completed the report and it didn't involve sitting down with the client for a potentially productive conversation. I was surprised that these account managers didn't have periodic and regularly scheduled meetings with clients. During our dialogue, the group seemed disheartened, defining themselves as "really just the complaints department."

There was no structured process for positive feedback and staff only heard from clients when things went wrong; by then, it was often too late to fix the problems. "They want us to wave our magic wands and make things better." (The lack of opportunity for positive feedback is a typical problem in organizations and in our culture.)

I noted to myself that therapists are typically expected to have a "magic wand" and sorting out this issue is always one of the first tasks of therapy. For example, when a parent brings a child to therapy, they have already tried and failed at everything. The tiny bit of hope they have left is projected as the looming powers and skills of the therapist which will make everything right, and fast. Naturally, therapy clients are likely to feel a deep dependence on the therapist and disappointment at the lack of a quick solution; resolution of the dependency and disappointment become major issues in the treatment.

Not unlike a therapeutic relationship, the account manager through the *Use of Self*[2] must achieve a working collaboration with their client. A theoretical difference, however, is that account managers and clients work together as *equals* toward a particular project *goal*. But here, often the client was not involved in the finished product and would only see it at the end.

To please the client could be a tall order for account managers when some problems had taken many months to build and involved several staff players, and when there tended to be few structured opportunities to work together. Typically, staff had little, if any, control over problems and empathized and even identified with clients' concerns from their own felt helplessness within a large bureaucratic organization. They wanted to streamline organizational processes to facilitate better client satisfaction.

I asked the obvious question: If having regular meetings with clients might prevent some of these problems? A monthly meeting to which clients were invited had already been instituted. Reportedly, clients sometimes came to these meetings and sometimes didn't. Some account managers said they hadn't heard about the meeting. This

2. "The Use of Self" is a term used in psychotherapy to help define the development of the therapeutic relationship. We think it was coined by family therapist Virginia Satir. More recently, it has become defined as an important component of organization development consulting by Edith and Charlie Seashore. Charlie wrote the Foreword to this book.

interchange indicated the inherent chaos of the larger system. I drew this on the mural toward the far right sidelines of the track.

MURAL NO. 2: "IDEAL SERVICE DELIVERY PATH"

In this mural, I focused on how to move the work of *engaging clients* forward. First, I needed to know how this seasoned group of account managers thought an ideal client relationship would look. Illustrating an ideal relationship would give them something to aspire to and a visual model from which to work. "What would an ideal framework for communication with clients look like?" I asked. "Should specific scripts for how to talk with clients be crafted and written in a how-to guide?" "What parts of the current model did staff want to keep?" The group acknowledged that their current system had pitfalls and was extremely subject to the vicissitudes of the individual personalities involved. In crafting a new system, they discussed the importance of a continuous improvement process for a new client outsourcing engagement protocol. They suggested developing questionnaires to measure client satisfaction and rating the effectiveness of the new outsourcing model.

Interpretation of Mural No. 2: "Ideal Service Delivery Path"

In Mural No. 2, I extended the track metaphor, turned it into a path without separate lanes and continued it to the far upper left corner of the mural; a rainbow arched over the end of the path. A client is walking merrily along representing the "Ideal Service Delivery Path." A client walking happily along and not looking back is the ideal situation account managers hope for and seldom encounter (Figure IV-2, center).

I marked the path with a large bulletin board titled "Successes." Feeling they were the "complaints" department, the group craved more focus on *success stories.* At the end of the path, or end of the track, metaphorically speaking, are "Lessons Learned" during the project cycle (Figure IV-2, middle right). Group participants described how they wanted to periodically sit down with the client for evaluation and feedback. This procedure was called "Lessons Learned" for the organization. Another form of evaluation would be the client's rating of the

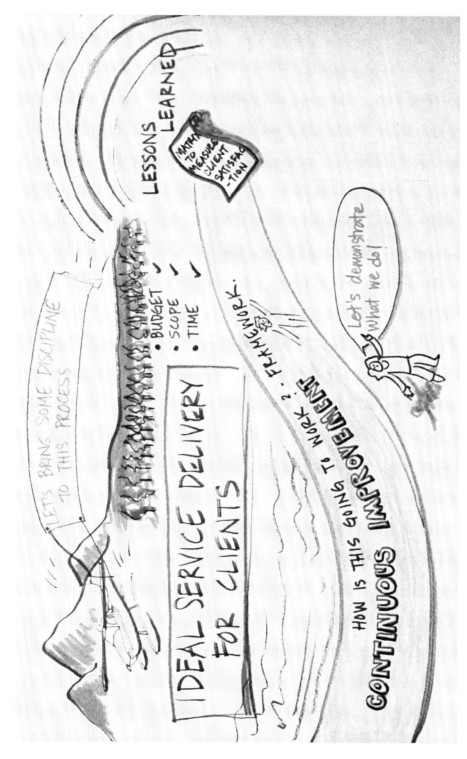

Figure IV-2. Ideal service delivery path. (Color version of this illustration can be viewed on the accompanying CD-ROM.)

account manager's performance during the project. (This was drawn on the mural at the end of the path, see Figure IV-2.) Through Graphic Facilitation, the group was able to grasp the real gaps in this client/account manager process and suggest a remedy.

Meanings of My Choice of the Jogging Track Metaphor

While this was a simple and "thought up on the spot" metaphor, it worked out well for the purposes of the meeting. It was personal to many staff and universal for others; thus it was easy to relate to. Although the metaphor of the jogging track was tailored to the needs of the particular situation and organization, within it, there is the more generalized symbolism of movement, competition, winning, and the potential to change directions. The Graphic Facilitator would do well to acquire a vocabulary of imagery for organizational use.[3]

The track image was open-ended–it could be as long or as short as needed–and thus gave me the flexibility to see what happened in the meeting so I had the ability to portray the shifts and emerging information into a whole visual image. As I look back, the jogging track suited the key organizational issues: a track has several lanes which can be used imagistically for exploring and comparing the roles of the different players including account managers, who participated in the meeting, and project managers, who did not. On the graphic track of Mural No. 1 (Figure IV-1), project managers were drawn getting ahead of account managers at times so that when a problem arose, the account managers would have to catch up. By the second mural, the track became a path of continuous improvement. It identifies activities along the way, such as success stories that would help engage clients and keep staff morale high. The rainbow at the end of the path suggests a happy ending. For account managers, the perfection at the close of the project, symbolized by the rainbow, implies the ideal perfection which is a dream they continue to aim for.

3. Please see References and Bibliography.

COMMENTS

Along with Graphic Facilitation documentation, I was also facilitating the meeting. Thus I needed to move back and forth between drawing and facilitating by paying attention to the agenda for the day and to what was happening in the room. I wanted everyone to understand the realities and complexities of the client engagement process so that we could all leave at the end of the day with a formulated *Action Plan* that would describe the steps needed to move ahead.

I didn't want to get bogged down in the anxiety *du jour,* of the "I am worried about losing my job" dynamic but encouraged the group to directly express its fears early on to get them out of the shadows and into the open air. I wanted the *secrets to be named* because as silence evaporated and came into the light, I knew the secrets would become less powerful. As in a family therapy session, the client may need to share their concerns before moving on. Participants worried: "This organization is making a big mistake outsourcing," "we're all going to lose our jobs," and "we'll become nothing but paper pushers." I did not want to concretize the almost-universal anxiety by focusing on it in the drawing. Here, I chose to keep these very important issues in words which would exist but would not have physical structure as a drawing element in the mural. In this way, I could acknowledge them as a "reality," but not codify them through drawing. This was an intuitive, probably unconscious decision which provides a good example of the difference between working as a psychotherapist and working as an organization consultant: If I had been functioning as a therapist, I might have chosen to include the staff's fears about job loss as the central theme of the mural. As an *organizational consultant,* however, I chose not to draw the anxiety about the unknowns of the new outsourcing plan. In this half-day meeting, we needed to primarily focus on positives so we could move forward.

Over the years, I've learned to be careful balancing my therapist self with my management consultant self. This is sometimes a dilemma for me and may be a problem for the art therapist new to organizational work. In organizational work, I am not being asked to assess or function as a therapist. I am employed by the client, usually upper management, to achieve certain goals, usually with staff. While my comfort and training might take me down a therapeutic path, under-

standing and even expressing psychological difficulties of staff indi-
viduals and even the psychopathology of the organization as a whole,
this isn't useful or appropriate in the business world. For example, the
client will not care if the whole staff is clinically depressed, if the goals
for the consultation are achieved. During our time together, I have to
fine tune my ability to connect with the group so they feel understood
but can then move forward with the task at hand. This makes Graphic
Facilitation challenging, difficult, exciting and quite different from
clinical work.

In the midst of the highly anxiety-filled, change-related initiative of
outsourcing, it was helpful for me, working as a Management Con-
sultant, to use Graphic Facilitation. The visual metaphors helped to
"carry" the meeting, to improve group dynamics, and to clarify com-
plicated information. The dilemma of outsourcing is a common one
today, and while companies compete to keep customers happy, they
need innovative strategies like Graphic Facilitation to thrive.

Chapter V

CASE STUDY NO. 3.
HOW CAN WE KEEP OUR KIDS
FROM KILLING EACH OTHER?

INTRODUCTION

In Case Study No. 3, a one-day meeting, or "summit," as the client called it, is described. The title of the event is "Collective Wisdom: Community Strength." I was hired as the Graphic Facilitator to work with another facilitator and other community leaders to lead the event. I drew three murals during the summit; two will be described here. One mural, "Birthing New Ideas" (Figure V-3), was drawn in the first part of the day during introductions and initial discussions. It documented the summit's theme of community strength and hope. The next mural, "Building Bridges"[1] (Figure V-1), represented a major theme of overcoming divisions in the community by building bridges of communication between generations, cultures, and across groups.

CLIENT

For this day-long community summit, my client was a youth project created by Yoland Trevino collaborating with a coalition of local leaders. It became a nonprofit group of community members dedicated to supporting community engagement and youth leadership development. Trevino was a visionary, a community leader living in the

1. Although I drew this mural after the "Birthing New Ideas" mural on the day of the event, it holds a more central role in this case study. Therefore, I placed it first.

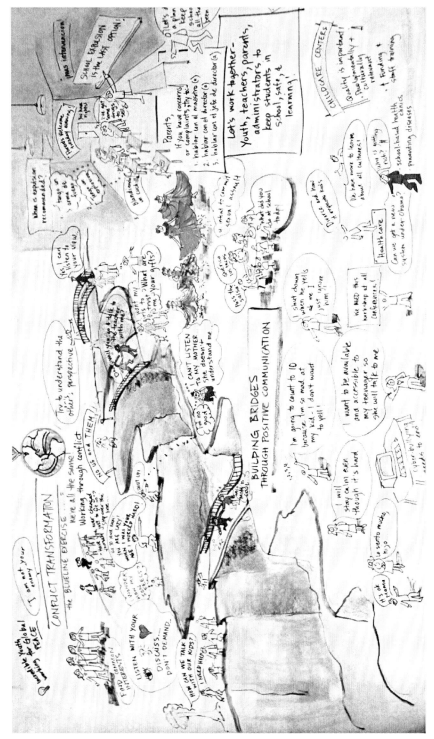

Figure V-1. Mural No 2: Building bridges. (Color version of this illustration can be viewed on the accompanying CD-ROM.)

area, and a parent herself. These groups came together to host the summit because of their common interest in creating strong, local communities. About 100 parents, youth, community leaders, and social service professionals coalesced for the bilingual English/Spanish event.

BACKGROUND

In 2008, a community in the greater Los Angeles, California area struggled with a resurgence of gang violence, particularly between Latino and African-American youth. Community leaders, teachers, and parents grew fearful and concerned for their children; they wanted to do something about the violence. Local schools noticed an upsurge of bullying, fighting, absenteeism, and drug use. Losing hope that the school would help, parents struggled to find ways to help their children. Usually, school teachers desired to build stronger relationships with parents, but many parents were solely Spanish-speakers; they felt estranged from the schools and unable to talk with their children's teachers. Some were immigrants who would not approach the school because of the very real fear of deportation. Traditionally, many parents tended to be ashamed to talk directly with community professionals, such as counselors and probation officers because, in most cultures that they came from, it was looked upon as a sign of weakness. Parents were fearful of authorities and didn't envision them as able to promote a team effort including themselves. Professionals were viewed as a "class apart"–professionals' education and standing tended to separate them from the people they served. It was hoped that during the summit, parents could find the courage to ask for the help and support they needed. Professionals needed education in community mores as well and it was hoped that parents would help with this.

Responding to these considerable challenges, a summit planning committee of parents, youth, and community professionals held a series of informal meetings to prepare. They identified priorities and selected speakers from the community to help guide discussions and teach skills through a series of workshops. They described themselves as "a new resident movement evolving to create sustainable civic engagement" (Y. Trevino, personal communication, 2008).

REQUEST

Yoland Trevino, a facilitator I worked with regularly, asked if I was available for this event. She knew my work and had been a strong advocate of Graphic Facilitation for years. As we discussed the summit, Trevino said she was convinced the murals would create a level ground for the diverse groups involved, which would give voice to participants who might otherwise be hesitant to speak up. At other events, Trevino had witnessed how well the Graphic Facilitation process worked and she was sure this group could benefit. With participants ranging from highly-educated professionals to youth and parents not accustomed to speaking in large groups or in English, Graphic Facilitation could visually include everyone in the process. I immediately agreed to participate in this project because I was fascinated with the challenge of integrating exceptionally diverse communities. Moreover, I knew and had worked well with Trevino for several years and was always pleased to work with her.

PREPARATORY MEETINGS WITH CLIENT

In the weeks before the event, I had two preparatory meetings with the client on the telephone. I spoke with Trevino who functioned as the lead facilitator, and, on a separate call, talked to one of the community leaders who co-sponsored the summit. He was the Executive Director of a local social services agency invested in the welfare of community youth. Separately, Trevino and the Executive Director described the issues of youth violence facing the community, the hoped-for outcome of the planning meetings leading up to the event, and how the agenda for the summit had been shaped. In my preparatory telephone meetings, we talked about what I could contribute, how I saw my role in the context of the agenda, the purpose of the event, and logistics. (This included how I would negotiate drawing in workshops scheduled to be conducted in separate classrooms around the community education center.) Some workshops would be facilitated in Spanish and some in English. I speak Spanish, which made this process easier for me.

As I typically do in this kind of situation, I asked Trevino and the Executive Director to anticipate which of the workshops would be about difficult topics and most likely would generate heated conversations. These are usually the best workshops for me to illustrate because the graphic process helps modulate anxiety in the room and stabilizes emotions so the group can go into more depth. I assumed these people were going to be dealing with tough, painful issues, and the facilitators would know where I might be most helpful. I shared my thoughts with Trevino and we decided together which workshops I should attend. I could still remain flexible so that I would decide at the time if I should leave one workshop for another depending on the content and energy of the group.

LOGO DESIGN

Previous to the event, the client called upon my skills as a graphic designer and asked me to design a logo that could be used on posters, brochures, and registration forms for the summit. We discussed themes, style, colors, and words, and I agreed to send samples within a couple of days. The client wanted something to symbolize the theme of the summit, *collective wisdom, community strength.* The logo they selected is shown in Figure V-2.

At the client's request, I drew the logo in both English and Spanish (the Spanish version is pictured here). I chose three figures holding hands dancing across the page. The figures are colored in yellow, dark brown, and pink to indicate three different cultural groups. Holding hands, the figures dance on a green path. The path begins between four houses, representing the four different communities involved. Figures and community are centered across an abstraction of a globe, representing a global community. I used colored pencil crayons for the logo. Rather than a slick, sophisticated graphic, I wanted a natural, home-made style that looked like what anyone might create. I felt this was more suitable for the desired ambiance of the summit to come. Markers or computer-generated graphics would have been too slick and would not have provided the look of accessibility, invitation, and inclusion the client was asking for.

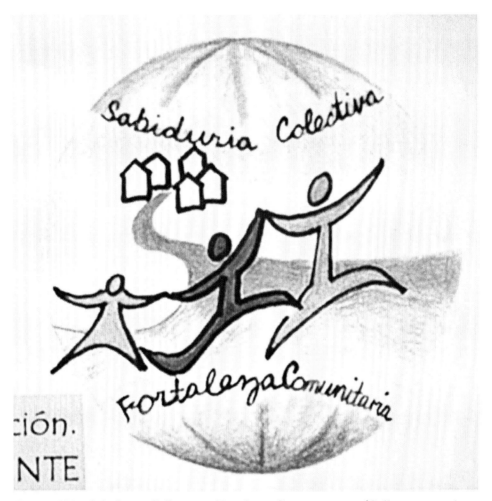

Figure V-2. Sabiduria Collectiva: Fortaleza Communitaria (Collection wisdom: Community strength) logo. (Color version of this illustration can be viewed on the accompanying CD-ROM.)

LEAD FACILITATOR

Yoland Trevino was the lead facilitator for the event. She coordinated the participating speakers and facilitators. Most were community leaders, teachers, and local mental health professionals who specialized in conducting parenting classes. My role as the Graphic Facilitator for this event involved collaborating with several facilitators throughout the day.

EVENT

The meeting started early with breakfast and mingling at 7:30 a.m. at a community education center. The main room was festively decorated with balloons, flowers on the tables, and music playing while people arrived and we drank coffee. Participants greeted each other warmly, mostly in Spanish, hugging and kissing. As an outsider, they seemed to me to be a vibrant and close-knit community. The room was spacious, leaving a lot of space to walk between the dozen or so round tables. As they entered the room, I introduced myself to as many participants as possible including the facilitators I had spoken with on the phone but had not yet met in person. I had already set up my mural paper along a side wall.

Graphic Facilitation in a Bilingual Environment

This event was bilingual. Speakers generally talked to the group in their preferred language. Many spoke in Spanish while a peer simultaneously translated, or they themselves would speak in Spanish and later in English, translate what they had said a few sentences earlier. English speakers also had Trevino or a peer translate into Spanish while they spoke to the group. The translation was not formally organized or prescriptive; there was a gentle back and forth, with participants feeling comfortable asking if they needed a word or phrase translated on the spot. As I listened to lunch and break conversations, it seemed that about three-quarters of the participants in the room primarily spoke Spanish. Many were Latino—mostly from Mexico and Central America. Several African-Americans in attendance spoke Spanish well and participated in both languages.

On the murals, I chose to work primarily in English. However, some of the workshops were conducted predominantly in Spanish without translation, depending on the needs of the group members who attended. For these workshops, I wrote in Spanish and English, keeping in mind that others who were not at the workshops might want to view the murals later. At the end of the day when I described the murals to the large group—walking them through them—one of the facilitators stood beside me and translated what I said and what I had written. The inherent linguistic and cultural divide evident in the room early in the day apparently was surmounted with ease and creativity.

Welcoming

As breakfast ended, Trevino[2] welcomed everyone and introduced the facilitators. She set a warm, upbeat tone by speaking from her heart about how much she valued this community and specifically the youth. She shared her vision of the youth as leaders in their own right, encouraging them to share stories to help parents and professionals understand them and their needs better. Immediately I began to draw.

I drew a large banner with the summit title in blue marker, "Collective Wisdom: Community Strength." Several figures stand under the flag holding it high above their heads. These figures represented the first few speakers and had word balloons coming out of their mouths. On the mural, Superintendent Gracielo's word balloon says: "Building on current enthusiasm," and "Anyone can be who they want (thanks, Obama)." In the meeting, Gracielo spoke about rallying behind President Obama's success as he had won the presidential election in the face of continued racism in America. Gracielo said he was inspired by the country's enthusiasm for President Obama, and used it as a platform to talk about the cross-cultural bridges he hoped would grow out of the summit. Alma Gomez, the councilwoman's representative, talked about the prevention of violence through her involvement with the youth, families, and neighbors' committee. In the mural, she is portrayed as the figure under the right corner of the banner (Figure V-3, right top). Another speaker, drawn on the mural under the left corner of the banner and wearing black pants, talked about the past and "reconnecting with family wisdom." She described what she had learned from generations of stories passed down to her from ancestors.

On the mural above the banner, I drew several buildings–including a church–an important landmark in most Latino and African-American communities (Figure V-3, top). Drawings of balloons floating up from the banner illustrated the celebratory spirit the facilitators hoped for from the day.

2. Note: Except for Yoland Trevino, all names have been changed.

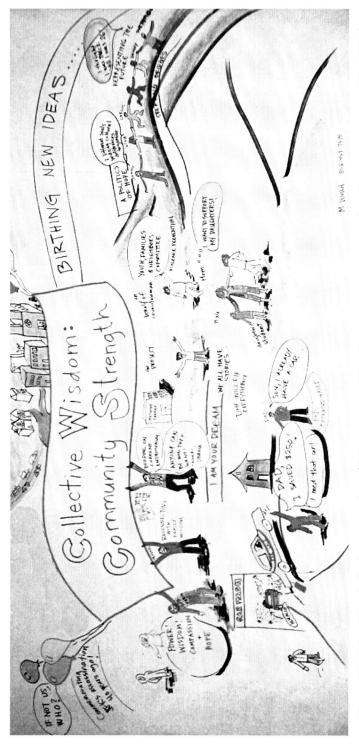

Figure V-3. Mural No. 1: Birthing new ideas. (Color version of this illustration can be viewed on the accompanying CD-ROM.)

Memories of Robert Kennedy Evoke Personal Memories

Upper left in the mural (Figure V-3) is a bubble that says commemorating RFK's assassination 40 years ago." The group reflected on the parallels between that time 40 years ago, when political unrest and cultural divisions in the country seemed insurmountable, and the present. Similar to what many had experienced 40 years ago, they felt their community now was at peril and they had experienced a loss of hope as they grew concerned about increasing violence. On the mural, a figure standing center left says, "Power, wisdom, compassion, and hope," summarizing the group's thoughts about what RFK's assassination meant to them and what they hoped for in their own journey as a community.

The group moved on to personal stories; I drew as I listened. Antonio, a Program Coordinator in a parent and community services agency, gave a keynote talk about the power of parent-child relationships. He reminisced about his own troubled youth. I drew his story in the bottom left of the mural (Figure V-3). Pictured is a teenage Antonio under his father's demanding and nurturing eye. He works at a car wash, where he learns discipline and hard-work. Antonio remembered wanting a car so badly that he saved all of his earnings to buy one. He remembered how pivotal his relationship with his father was, and how he continues to remember his memories of his dad's support.

Another parent, Maria Luisa, came to the summit with one of her two daughters. She shared her stories of raising them, her difficulties and dreams for a strong future. (Maria Luisa and her daughters are pictured in the middle of the mural.) At center right, several youth of different ethnicities are drawn walking together and holding hands; they represented a vision of the future for this community. In the vision, youth are at peace and united, regardless of color or culture. The path is called "A Politics of Hope" (the possibilities of hope were inspired by the new Barack Obama presidency).

One of the speakers, a parent, told a story of his own involvement in gangs as a youth. Latino, he grew up in an African-American neighbourhood, and said, "I thought I was black 'til I was 26!" When he realized he was Latino, he felt confused. In the mural, he is the figure with the caption on the far right of the mural, holding hands with the other youth (Figure V-3, right). I could see how powerful these stories were for the participants. There was enthusiastic applause after each

speaker, with youth sometimes shouting out cheers of support for the speakers.

"Appreciative Inquiry" Format Described

The lead facilitator described the "Appreciative Inquiry" technique we would use for discussions during the day. Appreciative Inquiry was originally adopted from earlier action research theories and practices and later was further developed by Suresh Srivastva and David Cooperrider of Case Western Reserve University, School of Management and in the 1980s (Cooperrider, 1986, Cooperrider & Srivastva, 1987; Hammond, 1996; Watkins & Mohr, 2001; Royal & Hammond, 2001). While problem solving had been the previous major organizational model, Appreciative Inquiry has become a popular, contemporary tool which engages participants through storytelling and inquiry to focus on *what works well.* It is usually a "5D" model: Definition, Discovery, Dream, Design, and Delivery. The goal is the emergence of an egalitarian organization (Srivastva & Cooperrider, 1986; Cooperrider, 1986). It works particularly well with difficult conversations, which was exactly what the planning committee and facilitators anticipated for this summit.

While Drawing, I Encounter a Community Searching for Solutions to Help Their Youth

Consistent with the Appreciative Inquiry Model, group participants engaged in an exercise Trevino called a "discovery process." They paired up with someone they didn't know and shared "two wishes for creating an effective partnership with parents, youth, and professionals." After this dialogue, participants shared their wishes with the larger group. I listened carefully and jotted down key phrases in my sketchbook, to weave into the next mural. My description of this mural follows.

MURAL NO. 2: "BUILDING BRIDGES"

Please refer to Figure V-1, Mural No. 2 "Building Bridges," at the beginning of this Case Study.

The group was asked to participate in an exercise called the "Blue Line." Everyone was instructed to gather in one area on the floor where the tables were cleared away. A long line marked with blue masking tape cut across the floor. Everyone lined up on one side of the tape. One of the facilitators called out questions in English and Spanish, such as, "Have you ever changed yourself just to fit in?" If participants answered "yes," they were asked to step across the blue line. This exercise was intended to break down notions of difference and set the stage for empathy and common understanding. The group could see themselves reflected in each other's difficult experiences through the process and people were laughing, crying, making jokes, and pausing to reflect. I watched group participants light up when they saw others expressing similar views simply by being honest and stepping over the blue line on the floor. Wanting to capture the essence of the experience on the mural, I turned to watch. In the upper left portion of the mural (Figure V-1), I drew several figures in motion on a blue ground. Under the heading "the Blue Line Exercise," I wrote "We're all the same!"

Workshop 1: Communication: Parents and Children

After a short break, for the next 75 minutes, participants chose a workshop to attend based on their own particular interest. Topics included "Youth Employment," "Affordable Housing," "Health Care for Undocumented Persons," "Successful Communication with Parents and Youth," and "Conflict Transformation." I had been told that one of the key goals of the day was to enhance collaboration across age groups, cultures, and professions; I found that all workshops I illustrated were related to improving communication.

First, I went to the "Successful Communication with Parents and Youth" workshop. I was nervous because the workshop was to be in Spanish only, and although my Spanish was acceptable, it was not fluent; working in Spanish added another dimension of complexity to my own processing of words, metaphor, and imagery. I needed to listen more intently, translate the words into English in my mind, and then select what metaphors and phrases merited documentation on the mural. This process increased my empathy in that it gave me a good sense of what it was like for the summit participants to struggle with an unfamiliar language.

Workshop members were so welcoming and helpful to me as I sat at the side of the classroom doodling in a large sketchbook, that I felt free to ask when I didn't understand a phrase or word, and they would explain it or my neighbors would draw it for me in my sketchbook. In this way, we naturally achieved a collaborative and stimulating effort. As a family art therapist, I was in my element with this topic and felt very encouraged by the parents' attempts to improve their communication with teachers and their children, and thereby improve their relationships in general.

During this first workshop, I saw youth and their parents trying to build bridges of communication. In the middle left of Mural No. 2 (Figure V-1) I drew a figure asking, "How can we talk with our kids?" Another says, "We need help." They are standing near the first bridge over the chasm. In another word bubble, the facilitator talked about what she had found helpful when communicating with children: "Listen with your eyes, ears, and heart. Discuss, don't demand" (Figure V-1, far left, center). I drew an eye, an ear, and a heart on the mural instead of writing words. Slightly below and to the right on the mural, three figures are walking over the bridge together; a youth is thinking "My mom is so cool" (I wanted to convey hope that listening to teens brings results). Of course, teens generally don't say these things out loud, so I drew it as a thought bubble (small circles leading to a cloud) rather than a word bubble.

On the same side of the chasm in the mural are other parents shouting at their kids: "Go to your room, you're lazy. When I was your age I worked hard!" One figure in the mural points to his child on the other side of the chasm and says, "Shut up." The child, huddled in a squat with his hands covering his ears (Figure V-1, center), is thinking to himself, "I am no good" and "I can't listen to my Mom. She doesn't understand me." These situations, showing ineffective communication styles, represented cautionary tales discussed in the workshop about how *not* to bridge relationship issues.

The group discussed practical strategies for dealing with tough parent-child relationships: a figure in the center right of the mural says, *"Lo siento mucho, hijo"* (I'm very sorry, son). A small figure nearby is saying, "It's OK, Mama." Another figure beside them on the mural says, "I'm going to count to ten because I'm so mad at my child and I don't want to yell." A youth in the mural, reflecting on what happens

in his communication with his father says: "I shut down when he yells at me. I ignore him."

"Dad, will you go and talk to the teacher with me?" says a youth on the second bridge of the mural (center left). He takes his parent by the hand to cross to the other side, eliminating the metaphoric chasm of disconnection. Another scene in the mural (to the right of the chasm) is a family sitting around the dinner table talking, *"Que rico, los tacos"* (the tacos are delicious), and "pass the *salsa*. . . ." This family is communicating over food which is often less-threatening for adolescents and their parents than direct confrontation. They talk about what's going on in their lives.

Workshop 2: Communication: Parents, Teachers, and Schools

The next workshop I illustrated was called "School Expulsion: What Can We Do Now?" It was led by a teacher from a local school. Most of the participants were parents who wanted to know how to help their children stay in school or prevent repeated expulsion. Many of these parents did not know how to deal with the American school system. They were raised in an environment where a school teacher was respected and honored *from a distance.* In the American system, the teacher and parents are ideally considered *a team* functioning together to further the students' education. Workshop participants talked about their challenges, wondering how to approach teachers, how to talk with their kids, how to set limits. The facilitator was supportive and informative, giving practical tips about their rights as parents in this particular school district system. She answered parents' questions patiently and provided suggestions for specific scenarios parents brought up: "How do I know if my child is skipping classes? How do I talk to the teacher if he doesn't even know who I am? I am afraid I will make my son angry if I talk to the principal." The facilitator gave clear, valuable advice to enable these parents to deal more effectively with their children's schools.

I could tell that this information was essential for parents and for their children and would effectively help them approach the educational system. As they absorbed it, it would become an important part of the learning from the meeting. Putting the information in graphic imagery in the mural helped capture the lessons in visual form and

would make them concrete and memorable. (I remembered early church art in which visual stories were told without words.) I quickly sketched a classroom, parents, teachers, and students, and important phrases in my sketchbook. I would later synthesize this information and transfer it onto the mural during the lunch break.

My drawing shows a classroom, with a teacher pointing at the blackboard, saying "school expulsion is the last option!" The figure's arm is intentionally oversized, as if to declare, "This is important!" In order to help educate parents and students, so they could advocate about inappropriate suspensions, I added the information taught during the workshop to the mural—specifically, the list of five reasons when expulsion is recommended. These are transcribed as cartoon word balloons bubbling up in the minds of students sitting in desks in the classroom. The students are pondering their thoughts, as if hoping to find better options. Their thoughts are:

1. *Tengo un arma de fuego* (I have a weapon),
2. *Tengo un explosive* (I have a bomb),
3. *Blandiendo un cuchillo* (I'm carrying a blade),
4. I intend to commit sexual assault,
5. I've got some drugs to sell.

Shocking, factual examples enabled parents to better understand the pressures their youth faced. From the way they spoke during the workshop, it was apparent that while some parents found violence familiar, having grown up in similar environments themselves, for others, this was a terrifying new situation in a strange land. Some blamed themselves for leaving their native country and exposing their children to unforeseen dangers. Parents expressed their own frustrations and fears during the workshop, and I participated in the conversation from time to time providing reflections.

Over the door to the classroom in the mural (Figure V-1, upper right), there is a banner saying, "Parents Welcome, Tuesday evening." The facilitator urged all parents to get to know their child's teachers by attending parent-teacher evenings. More helpful tips or reminders from the workshop are recorded in the mural where I added a bold flyer instructing, "Parents, if you have concerns or complaints, try to:

1. *Hablar con el maestro* (talk to the teacher),
2. *Hablar con el director* (talk to the principal),
3. *Hablar con el jefe de director* (talk to the superintendent)."

Although my purpose in adding this advice had been to record it for the educational element of the day, the suggestions clearly evoked many questions and fears for the group. As is often the case, visual content provoked and stimulated, rather than simply capturing. Some participants talked about how, because they were illiterate, they felt ashamed to approach school staff. They felt they couldn't help their children with homework, and didn't have funds to pay for tutors. Their own sense of shame about themselves impacted their relationship with their children and with the school. The anguish was real; they were dealing with tough, potentially life-threatening situations, often in the midst of poverty, lack of health care, and lack of adequate support systems. With the recent rise of youth violence in their community at the forefront of their minds, parents were worried about their children getting shot, being involved in drugs, leaving school, and running away from home. Several cried when they told their stories about their kids not coming home at night, or becoming involved with police. Helplessness and sadness pervaded the room. The mood of celebration from earlier in the day was replaced by the acknowledgement of the many unfortunate realities. But at the same time, I hoped that the community was learning new skills which could lead to more feelings of empowerment. I hoped that this sense of empowerment would be reinforced as I documented lessons on the mural.

Lunchtime and Mexican Folkloric Dancing

Lunchtime was festive with a delicious spread of hot food, and dancing. As usual, I gave myself only a few minutes to eat because I wanted to continue drawing. The shift in atmosphere to lunch from the last workshop was pleasing to group participants, of course, and I noticed many were laughing and eating with each other. On the mural, I drew the dancers (Figure V- 1, center right) because I felt they were a vibrant symbol of the community spirit evident at this summit–underneath the sadness. Organizers had wanted to make the day an enjoyable event for the group, and it seemed appropriate that most of the dancers were youth, probably from the community, indicating that

there were other paths for children here, even beside the tremendously difficult realities of this world.

DESCRIPTION AND INTERPRETATION OF THE MURALS

Meanings and My Choice of the Metaphor

Mural 1: "Birthing New Ideas"

Mural 1 focuses on the people who introduced the day, identifying most of the speakers by first name and providing a few highlights of their individual speeches or stories. The figures are appropriate for this introductory mural, because this summit was about relationship building throughout the community. The goal of the summit was to connect with others in order to birth new ideas for reducing violence.

Mural 2: "Building Bridges"

As the group broke and headed downstairs to the main room for lunch, I was ruminating about an overarching metaphor for the main mural. As they usually are, I knew my own feelings about the workshops would be my guide. I felt the anguish of this community–like a chasm under my feet, ready to swallow me up. Was this how participants felt? It reminded me of an earthquake, a common occurrence in this part of the world. When the ground rumbles and cracks beneath you, you understand there is no control. From parents, I felt their sense of helplessness and loss of control over their kids.

Perhaps the inevitability of an earthquake creates a primitive, archetypal fear, but it is also a probable and potential reality, like these families' fears of losing their children to violence or drugs. I recalled being at the epicenter of the Northridge, California earthquake in 1993 when I was an art therapy intern, working with elementary school children and during aftershocks in the days following the quake. Every time there was a bit of movement, whether an aftershock to the quake or a truck driving by, we dove under the desks. Now would we call this Post-Traumatic Stress Disorder? Was this what community parents could be feeling?

So I settled on the metaphor of the chasm. But following positive tenets of Appreciative Inquiry, I imagined a beautiful canyon with

desert-colored earth akin to the California landscapes I so loved, and the chasm became a canyon from which riches might grow.

Under the Blue Line exercise, I drew a large chasm (Figure V-1, center). I added a river flowing through the canyon as a symbol of renewal, and colored it brightly with blue chalk to make it "pop" against the ochre canyon walls. Over time, a river has the power to carve out land and canyons—new structures in the earth. It also supports the potential of growth—of plants, of wildlife, and of humans. Although my canyon drawing was bare, river waters carried the hope of life and opportunities.

I was careful to leave enough room on the page to incorporate more material that I knew would come later in the day. I also had several sketches from the first workshop, concerning successful communication with parents and youth, that needed to be integrated into the mural. During lunchtime, I transferred these graphic notes onto the mural (Figure V-1, center bottom).

In this mural, the canyon splits the landscape into two halves, with the river weaving through the cliff-face miles below. The question the picture asks is, "how can these two halves be bridged?" The answer from the day's events was "through communication." The canyon's halves represented the diversity in the room: culture, race, age, and language. Youth and their parents divided, teachers and parents divided, Latinos and African-Americans divided, Spanish-speakers and English-speakers divided. This was a community of people trying to figure out how to *connect,* how to be understood, how to bridge the deep chasm between them, how to live together comfortably.

The purpose of this summit event was to bridge these differences through relationship-building, sharing personal wisdom and strength, thereby transforming conflict. This main mural (Mural No. 2) is titled "Building Bridges." Participants were working hard at crossing the chasms that cut through their community and even their families. Bridge building was both the content and the process of the event. I witnessed the telling of stories, tears, anger, and celebrations, which broke down feelings of isolation and desperation. I was humbled to be part of this expression, and impressed with the community activism aroused because of the event.

The name of the event was "summit." There was a pleasant irony in my use of the chasm/canyon metaphor. I probably intuitively con-

tinued the language of landscape, through Graphic Facilitation, and it was only later that I recognized it as a universal language. Many group participants had left their homeland to travel to a new place. Many came to a new land as immigrants to make a better life for their children. But in this foreign ground nothing was easy. They struggled to establish a new home as they struggled to learn a new language and understand foreign cultural mores. Their children, assuming some of the values of the new land more easily, grew distant from them and many crossed the chasm and were lost. Apparent were the twin ironies of the immigrant: the loss of one's homeland because of the urge for something better for their children co-existing with tremendous difficulties and even casualties within the potential growth and opportunities of change.

A "summit" is a meeting of high-level officials, but it is also means the highest point attainable. Through improved communication, perhaps parents and youth might arrive together at the summit. I hoped so.

COMMENTS

Through the imagery of Graphic Facilitation, the group felt a structured containment in which they could express their emotions. On the mural, they could see and be proud of their accomplishments as they became more willing to accept the intensity of the situation with their children. Graphics illustrated the vibrant color of their stories, the deep sadness in their heart, and enabled them to express their worst fear—that in this new land, they had arrived at an unbridgeable chasm which could divide them forever from their children.

As Graphic Facilitator, I attempted to create a *picture of their own words*. Despite the desperate ugliness of some of their day-to-day realities, it was a beautiful picture. I was saying, "It is OK to feel what you feel." I was also saying, "Now, here is the hope." I gave the murals to the event participants to hang in a suitable space where they might use it as an on-going image of their challenges and their possibilities. Later, participants might return to the mural images, to be reminded of the hope—through their collective learning—they were able to find during that day.

Chapter VI

CASE STUDY NO. 4. TOWARD INCLUSIVE GOVERNANCE: GRAPHIC FACILITATION AS A TEACHING TOOL

INTRODUCTION

In Case Study No. 4, I describe two meetings I facilitated for a client. I worked with this client and associated organizations for several years in a statewide project. In this case study, I focus on Graphic Facilitation in two murals. These murals demonstrate the power of Graphic Facilitation to teach difficult concepts to diverse audiences by encouraging participation in dialogue.

In the first mural, "Performance Accountability" (Figure VI-1), the metaphor of a gymnast progressively learning to perform a cartwheel with the support of her coach parallels the performance accountability concept the facilitator wanted the group to learn. (In retrospect, although this metaphor was suggested by a Latino group participant, I wonder about the gymnast image as gymnastics historically is a predominantly Caucasian sport.)

The second mural, "Community Empowerment Through Data Gathering" (Figure VI-2), illustrates the strong educational component of this Graphic Facilitation process. It shows a vibrant town street scene with community residents going door-to-door, actively participating in shaping the programs they deem valuable for children in their community. Based on the facilitator's description of a local success story, the drawing developed during the meeting as her dialogue with the group evolved.

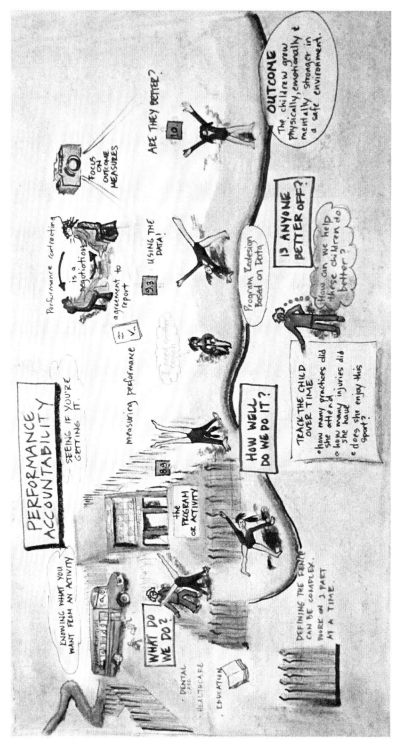

Figure VI-1. Performance accountability. (Color version of this illustration can be viewed on the accompanying CD-ROM.)

BACKGROUND

In November 1998, California state voters passed the Children and Families Act, an initiative that increased taxes on tobacco products, and thereby generated approximately $700 million per year for the state. Each county received a portion of these funds based on the number of live births. Counties were mandated to put this revenue toward programs that improved the well-being of children—prenatal to five years old. These programs were intended to prepare children to enter school ready to learn, physically, mentally, socially, and developmentally. Counties set up commissions to dispense and monitor funding. Four county commissions consulted with a statewide organization, known as the Foundation Consortium,[1] to help them determine how best to deliver, monitor, and evaluate the use of funding. The Foundation Consortium had expertise in program monitoring and evaluation. A partnership was set up between the four counties with the support of the Foundation Consortium and was called the "Results for Children Initiative." This partnership was my client.

The Results for Children Initiative (RCI) pursued a governance model called "Inclusive Governance." As a group, the RCI challenged itself to uphold and implement inclusive governance while monitoring program funds across their counties. A key principle of the "model requires bringing multiple solutions to the forefront by drawing on the perspectives of *all stakeholders*." For programs serving children, prenatal to five and their families, "stakeholders" consisted of the recipients of services who knew what services were needed and how they should be offered, residents who knew their community's needs, funders and policy makers who provided resources and structure, and service providers who brought skills to help solve problems. RCI believed that "Inclusive Governance" principles and practices could help achieve more equitable results for young children across ethnic, cultural, linguistic, and economic lines. It could help RCI be knowledgeable about specific strategies for different populations and be able to interpret data to hold themselves accountable. Using "Inclusive Governance" would also help RCI become aware about program effectiveness and if specific programs had difficulties reaching certain populations.

1. Leticia Alejandrez was a Program Director for the Foundation Consortium.

To achieve inclusive governance, the client needed to insure equal representation of all community groups. For example, the Hmong population in the central valley would need to be encouraged to participate in the governing of these programs, as well as the large Latino population in each of the counties. Hmong are people originally living in mountain villages in southern China and areas of Vietnam, Laos, and Thailand. Many immigrated to the United States after the Vietnam War and lived in the region.

The inclusive governance model also involved *performance accountability:* The Foundation Consortium asked counties receiving funds to measure the results of what they were doing, which meant they would have to decide what they wanted to measure, who it would serve, and if the recipients would be better off in the end or not? To govern "inclusively" meant that no one program director could choose what to measure for the whole community. The goals and the focus of these Results for Children meetings included:

- Bringing everyone together to begin the process of choosing what to measure,
- Deciding how to measure it, and then
- Measuring it with participation from the communities involved (L. Alejandrez, personal communication 2006).

CLIENT

My client, the Results for Children Initiative (RCI), was the partnership organization created by the Foundation Consortium and the four county commissions. A lead facilitator of the organization knew my work and encouraged their Board of Directors to hire me. She convinced them that the diverse, multilingual, multicultural audiences invited to these events would need innovative modalities to learn how to run their children's programs, and that Graphic Facilitation could provide this.

REQUEST

I met with the executive director of the Foundation Consortium and one of her program directors to discuss my role in the meetings.

The client planned to convene several three-day "academies" across the state to jump-start community conversations about what mattered for children. The Foundation proposed to maximize participation by reaching out to the diverse communities the programs would serve and, in the meetings, teach the major concepts of program development and evaluation. The program director explained to me that community leaders, service providers (such as counselors, childcare providers, and nurses), parents and grandparents, commissioners, and politicians were invited to the academies. Each academy would have a different flavor based on its location and the cultural qualities of the attendees. The facilitator who had recommended my services would be taking a major role in many of these meetings. She believed my participation in the project as Graphic Facilitator would strengthen the impact of the community dialogues and make them more accessible to all participants.

PREPARATORY MEETINGS WITH CLIENT

After meeting with the executive director and program director, I had two meetings with the lead facilitator to prepare for the events. She helped me understand the organization's objectives, explained some of the concepts, and agreed to send me background materials, such as policy briefs on inclusive governance models and recent strategic planning meeting minutes from the Board of Directors. We also went over the facilitators' agenda for the first event and decided where I might draw when multiple workshops were scheduled.

EVENT

The first meeting I describe was a workshop within one of the three-day academies. A facilitator guided a discussion about the concept of performance accountability. At first, I felt uninterested in the subject because I didn't understand it. It seemed reminiscent of the latest trend toward solution-focused therapies dominating the managed health care market at the time.

Setting up for the workshop, I was asked to draw at the front of the room so that everyone could see the mural and interact with me. Of

the approximately 30 participants, most were Latino, with a few Cau-
casians, African-Americans, and Hmong. Strong, welcoming keynote
speeches were first. They praised the work of existing counties and
programs, their vision, and their strong commitment to the principles
of inclusivity. As they came together, meeting participants seemed
happy and energized. The lovely setting–a mission style hotel on the
coast–provided a relaxing change for many who were leaving stress-
ful jobs and demanding family lives for a few days to participate in the
event. Some participants had flown in, while many had driven from
neighboring inland farming areas. We had perfect weather and en-
joyed coffee breaks outside on bougainvillea-filled patios. The impor-
tance of physical environment to the success or failure of an event can-
not be underscored enough. Sometimes it can enhance openness and
help participants take chances. Sometimes it can provide a hindrance
to progress and development.

The facilitator started this workshop talking about what perfor-
mance accountability meant to her. "There isn't a right or wrong way
to do performance measurement work," she assured us, "but it has to
make sense to you. You will have to explain it to others in your orga-
nization and to your funders and help them understand." I was sched-
uled to illustrate this workshop.

Enthusiastic about the advantages of the Inclusive Governance
Model, the facilitator stated that she had seen it work for community
programs. Measurement of the performance of programs was also part
of the legislation that provided this funding, so it was important that
the group embraced it and understood it as well as possible.

The facilitator's goal was to teach the performance accountability
concept to the group thoroughly enough that they could bring it back
to their respective communities and, in turn, teach them. By imple-
menting the performance accountability model, programs could
insure continued funding. The facilitator asked, "What *is* performance
accountability? It's being accountable to clients for the performance of
the program. It's knowing what you want from an activity, and finding
out if you're getting it." I quickly jotted down this phrase on the mural
just above the title (Figure VI-1 upper left).

"We start with the fence drawing" the facilitator said. I started
drawing a fence even though it made no sense to me. *"We draw a fence
around the thing to be measured,"* she said. "We want you to measure pro-

grams that are valuable to the people in your community. How will you know if they are valuable? Is anyone better off after going through the program?" I was getting nervous, wondering how I could possibly draw this. I started drawing a community center inside the fence, knowing that was a common meeting place in most communities.

I Begin Drawing While the Group and I Struggle to Understand

"It's a different way of thinking," the facilitator warned us. Next, she asked us to think about what was *inside* the fence: "Who do you want to help? Who are your customers? Your clients? They are the direct recipients of the service, but also include others who depend on the program's performance, like the parents of children in a childcare program and the local elementary school where many of these children will enter kindergarten." Hearing this statement, I changed the building inside the fence to a childcare site, grabbing onto the first concrete example I had heard. The group seemed bewildered.

"How about an ESL program?" [English as a Second Language] someone suggested. I added an ESL sign to the childcare center. The mural was getting messy. I decided to hold off on drawing until the group and I came to some clarity and better understanding.

The facilitator persisted, questioning the group about what services would be provided in this program, how would they know that the clients were better off after being served, or that the services were done well? As group members responded, their answers generated a new path and understanding to the conversation. I drew their answers in the mural.

Description of Mural No. 1. "Performance Accountability"

On the far left of the mural sits a red brick building with a sign above its front door: "Gymnastics School, RCI, Ages 0-5." A young gymnast in a bodysuit performs a handstand with legs straddled, in front of the gymnastics school. She is supported by her coach who is holding her right leg to help keep her balanced. A balloon identifies this as "the program or activity." I drew a protective fence enclosing the gymnastics school. My intention was to symbolize a program and refer to what the facilitator had called "drawing a fence" or *defining the problem.*

One of the group members suggested the metaphor of the gymnast and gymnastics school–she said her daughter was taking gymnastics classes, and asked if the metaphor worked for the purposes of our discussion. I looked around the room and saw some nods; I responded by quickly sketching a girl gymnast in pencil on the mural. It was obvious to everyone in the room that I was learning about the concepts alongside them, and wasn't sure if this metaphor would stick. I threw out ideas verbally for metaphors that I thought might fit, hoping for a positive response from participants and the facilitator. But a couple of my ideas drew blank stares–not the response I wanted, so I dropped them. I suspect that my position at the front of the room put me in a "hot seat" which made the dialogue richer. I probably represented some unspoken group confusion and I believe the group benefited from seeing me squirm. Fortunately, I am inquisitive. The group and I both relaxed when the participant's suggestion of a gymnast seemed to resonate for the group and we could move forward with the mural.

My questions helped to normalize the group's sense of curiosity, encouraging them to freely toss out ideas. The facilitator explained why she felt each idea worked or didn't work, thus helping the group come up with ideas that matched the concepts more precisely. The conversation became an interactive dialogue which promoted a stimulating sense of collaboration. The room came alive. It was now no longer a "leader" giving out information and the "truth" to followers, but had transformed into a process in which all could be equals struggling together to reach a better "answer" than any one on their own could find.

It was the art that freed the group from their fears and enabled them to brainstorm and explore new ideas within the rich environment of a dynamic, newly-formed community. The concept of "Performance Accountability" had become clear to me. But, more importantly, it had become clear to the group members and, in their hands, it had achieved a sense of life.

Around the perimeter of the fence, I drew four subtitles on the mural: "Transportation," "Health Care," "Dental Care," and "Education." I drew symbols for each of the subtitles–a school bus, a Band-Aid, a happy, smiling child with a toothbrush, and a book. The facilitator described these four symbols as measures of a child's readiness to attend school. Bottom, left corner of the mural (Figure VI-1), between two

fence posts, I wrote the facilitator's warning: "Take it slow," she said. "Defining the fence can be complicated. Work on one part at a time."

In the center of the mural is a series of gymnasts representing different stages of accomplishing the goal–a cartwheel. First, a young gymnast (Figure VI-1, lower left, center) attempts a cartwheel. With left foot and left hand on the mat, right arm high over her head and right leg kicking in the air, she takes the first step. (The viewer gets a better sense of her position because of the shading drawn in black on the ground under her and the other gymnast figures. Making images as three-dimensional as possible helps murals come alive.)

Next, the gymnast advances to the second position in the cartwheel–a handstand with legs slightly straddled (Figure VI-1, center). Above is the number 8.9 in a box, to represent the gymnast's score out of 10 for her form and skill. The adjacent words, "measuring performance" indicates judging. Below the gymnast's hands, on the ground, is a box with the question, "How well do we do it?" This query refers to the judge's estimation of the quality of the gymnast's performance. Reflected in the performance are the skill of her coach in teaching the young gymnast and her *required form,* such as, are the girl's toes pointed, her knees locked, her elbows straight? A score of 8.9 out of 10 would be the marks of a decent cartwheel, with room for improvement. Of course, her score also indirectly reflects on the quality of the gymnastics school, which is pictured in the mural as "RCI."

Next, the gymnast sits on the ground facing us, hugging her knees. A bubble caption says, "I want another coach." She feels her present coach could have better prepared her, could have given her better instruction. She is discouraged and has reached an impasse. While drawing, I decided to use an individual person (the gymnast) for the metaphor–rather than a program or agency, to personalize the mural for the participants. In this situation, the gymnast in a huddled position makes the viewer feel the sense of discouragement. Any of us might have felt the same if things didn't go as well as they could have, and we were asked to do better next time. I felt that understanding a child's frustration and disappointment at not doing well enough would help the group remain engaged and empathic in the importance of preparing the program for success. Drawing an organization or agency has a less personal feel and connotation than the picture of a disappointed child.

Below the disgruntled child on the mural, a balloon says, "Program redesign based on data" (Figure VI-1, lower center). For any program to be successful, such as this gymnastics school, the coaches need to continuously adapt their coaching techniques to suit the individuals involved–in this case, the young girl. Data includes the score of 8.9, which the girl received for her cartwheel; her motivation faltered because she stopped practicing and she is sitting on the floor. The coach stands underneath the "program redesign" bullet. Beside and above him, a cloud with writing shows his thinking which reflects the program's accountability: "How can we help these children better?"

The gymnast continues practicing cartwheels, and she is next drawn almost completing the cartwheel, with right hand and foot on the floor, left arm and leg in the air (Figure VI-1, middle center, right). Above her, a score of 9.3 indicates that her performance has improved since the last cartwheel. Above her also is written: "using the data!" which implies that using the actual data of any program or activity can improve it. This story conveys that working with her coach and getting ongoing feedback helps the gymnast improve her form and skill.

Finally, the gymnast is drawn standing upright with legs apart and arms over her head in a finished presentation pose (Figure VI-1, far right, center). A mark of 10.0 is noted above her head; she has mastered the move. Above the mark of 10.0, I wrote "Are they better off?" which conveys the need to continuously monitor whether or not the children in the programs are getting better and are the desired outcomes achieved? Below the gymnast (Figure VI-1, far right, bottom), I drew a cloud filled in with this concept: "OUTCOME: the children grew physically, emotionally, and mentally stronger in a safe environment." Evaluators look for these outcomes when they assess programs to gain continued funding.

Also important for program evaluation is tracking a child's progress over time. A bullet in the center bottom of the mural says, "Track the child over time. How many practices did she attend? How many injuries did she have? Does she enjoy this sport?" (Figure VI-1). In dialogue with the facilitator, the group came up with these questions to customize the concept of the gymnastics school metaphor. If the child frequently missed practices, constantly sustained injuries, or wasn't enjoying her lessons, that information needed to be considered in the evaluation of the program. Group participants seemed to understand

the vicissitudes of program evaluation. I watched mental lightbulbs turning on as the group felt more and more comfortable with implementing the concept of performance accountability. The mural helped it all make sense.

The facilitator's final reminder to the group was: "Stay focused on outcome measures" (Figure VI-1, upper right). On the mural, a camera lens zooms into the words indicating the goal of program evaluation.

SECOND EVENT

A second mural, "Community Empowerment Through Data Gathering," was drawn a year later, at another event. Most of the 75 people who came to the second meeting had attended the first event. After the first meeting, the group had taken away lessons learned, practiced them in their communities and programs, evaluated progress, and brought back their learnings to share as they came together a year later.

DESCRIPTION AND INTERPRETATION OF THE MURAL

Mural 2 illustrates a story the facilitator shared about a successful data gathering project at a family resource center in one of the involved counties. The family resource center, that we will call "La Casa," received funds under the Children and Families First initiative. La Casa wanted to implement inclusive governance and performance accountability in the fabric of their programs. The facilitator offered the story of La Casa's efforts so that audience members would have a contextual reference for the potentially difficult concepts to enable them to accomplish this form of data gathering and evaluation in their own counties and programs.

Through the story, the facilitator attempted to bring inclusive governance closer to clients, community, and service providers by making sure voices typically omitted from decision-making were heard. (Groups often not involved in hierarchical decision making were people of color, residents of poor or disadvantaged areas, non-English-speakers, or young people). "Let's push our comfort zone, everyone,"

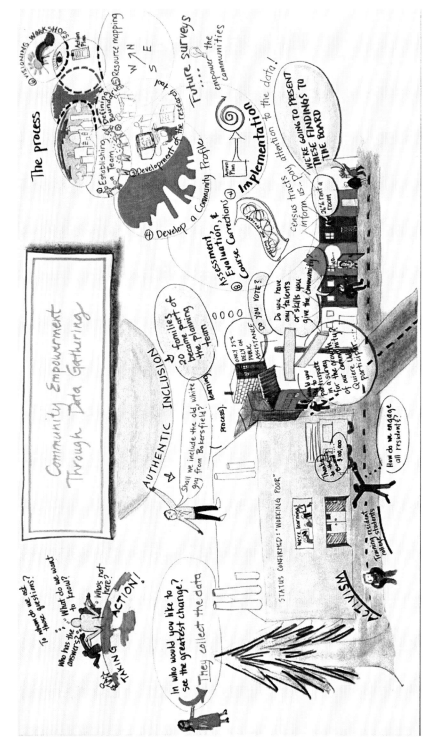

Figure VI-2. Community empowerment through data gathering. (Color version of this illustration can be viewed on the accompanying CD-ROM.)

the facilitator encouraged us. She asked us all to think creatively about how we could engage people we might normally never talk to about program development.

I listened intently as I attempted to find the right image to begin the drawing. I was positioned at the side of the room this time. Being out of direct sight lines made me more relaxed. I also felt comfortable working again with this group of lively and bright community-oriented people. The facilitator described her recollections of the process from the first event. A key concept of Inclusive Governance is soliciting input from the people representative of the demographics of the community. The facilitator remembered out loud that after the first event, 20 community families had become part of a planning team to decide what specific data should be gathered, from whom, and what the data might mean to the community. Community leaders and service providers also became part of the planning team.

The facilitator described the inclusive process:

> We made sure we could have the meetings at La Casa after work when families could come. We held them in whatever language people needed–usually English and Spanish. We welcomed children and youth and offered fun activities for them in the room. These were not formal, quiet meetings.
>
> We always served food–it showed we valued the cultural tradition of coming together over food. We asked the people to help us discover what this community wanted for its programs. What would make their children be better prepared for school at age five? How could they know if they were doing better? What were the signs to indicate they were doing well?

Standing by my empty mural paper, I imagined the neighborhood the facilitator talked about. I imagined multicolored houses on the same block as the family resource center. A street scene felt like the right metaphor–urban, dense, and vibrant, with the family resource center at the core. On the mural, I began drawing what I pictured in my mind. I started with two streets, and a large building (Figure VI-2, lower left). The family resource center is placed at the corner of Cesar Chavez and Montecito streets, as shown by the street signs. Under the sign identifying the building as "La Casa" it says "Status confirmed,

working poor." This was a reference to the fact that census data had described this community as "working poor" socioeconomically. Census data about this community indicated that 2.5 percent relied on public assistance, and 26 percent rented a room rather than an apartment or house (Figure VI-2, center, and center right).

In the center, left of the mural, a tall figure wearing a tie stands on top of the building saying, "Shall we include the old, white guy from Bakersfield?" The figure is pointing to a banner that says "Authentic Inclusion." This phrase represented the planning team's thinking process about who to include in the planning, implementation, and evaluation. Sometimes the voice of the "old, white guy" is not representative of the whole group but nonetheless needs to be included.

Left of the figure with the tie is a female figure who represents the event facilitator. She asks: "In whom would you like to see the greatest change? They [should] collect the data." For example, this idea meant that if the changes the community wanted to see were to be in youth, *youth must be involved in the development and measuring of outcomes.* Involving youth in data collection would already represent an important change in their participation as they became "owners" of the elicited data instead of mere (and often critical) "bystanders."

The planning team had high hopes for this community's young people. They talked about the potential they saw in their youth who were going to the local college. They hoped to watch them grow into leaders who would advocate for change at community and political levels; they wanted them to grow to effectively represent the community. A crucial decision was made that community youth would collect the data. In the street section of the mural, figures are walking door-to-door, talking to residents, asking questions, such as, "Do you have any talents or skills you give the community?" and, "Do you vote?" (Figure VI-2, center, lower right). At the intersection of the streets, a figure knocks on door and asks, "Would you like to participate in a survey for the growth of our community? *Quiere Usted participar?*" (spanish translation).

A figure on the mural asks himself a central question of all data collection: "How do we engage all residents?" (Figure VI-2, center, lower left). The facilitator explained the importance of collecting the information in the residents' first language. College students who collected the data in the neighborhood were bilingual and comfortable in both English and Spanish.

Toward the upper right corner, I drew several overlapping circles (Figure VI-2, top, right). These circles contain words and imagery to describe the data collection process used by La Casa:

1. Establishing a team,
2. Defining boundaries,
3. Developing the research tool,
4. Developing a community profile,
5. Resource mapping,
6. Visioning workshops,
7. Implementation, and
8. Assessment, evaluation, and course corrections.

This clear description of a step-by-step process provided structure to add to the story the facilitator had told. Laying out the process graphically made it accessible to the group by breaking it down into parts. I drew each part as a simple story within a circle, like stepping stones. The symbols in each circle for each step described by the facilitator were intended to help explain the concepts. One of my goals was to reduce the group's anxiety and give them another way of looking at information. These steps—along with the memory of how it had been done—would be a guide for participants when they returned to their counties. For example, the facilitator stated that the planning team kept mapping their process in order to keep it on course. Underneath Circle 8, I drew a scroll that says, "Mapping our process" (Figure VI, center right). Visually organizing information helped participants feel less overwhelmed, making them more available to engage. This is one of Graphic Facilitation's many values.

Upper left of the mural shows some key questions the planning team pondered before embarking on the project. Several figures with their palms up and shoulders hunched stand on a globe that says, "Taking action!" The yellow figure is thinking, "Who has the answers? What do we want to know about the answers? To whom do we ask those questions?" and "Who's not here?" These were major questions which helped frame the process and enabled participants to "draw the fence" around particular issues to be studied.

The workshop was structured in two ways: one was the success story told by the facilitator about an ideal scenario; the other was visu-

alizing the story with Graphic Facilitation methods and metaphors enabling a deeper spirit of communication. Establishing a focus for these considerable problems was not simple and we remembered the facilitator's early caution about complexity. But by the end of the second workshop, group participants understood the essential concepts presented and were ready to put them into action in their communities.

METAPHORS AS TEACHING TOOLS

Just as the facilitator's description of residents conducting a survey, by going door-to-door in this mostly Latino neighborhood made the data collection process come alive for the group, the mural took it to a new level. The street scene metaphor was a simple, accessible depiction of everyday life in this community. Data collection became less daunting and obscure and the concept of Inclusive Governance became meaningful. With this model of inclusion, families were seen as central to the programs and were therefore pivotal to any data collection. Interesting about the Inclusive Governance workshop was the parallel process reflected in the room: Parents who participated in programs watched me draw; they were not only part of data collection but were now teaching it to others through being part of this event. They knew their voices mattered because they had positive experiences helping to design and evaluate community programs. With Graphic Facilitation, families saw their ideas transformed into pictures in the murals. Although there were many lofty research and evaluation words on the murals, I am convinced that it was predominantly through the co-created imagery that the concepts *came alive* for participants. As this happened in an educative process, research ideas became less "unknowable," an integral part of group members and they were able to apply them—to teach others and to put program evaluation into practice.

COMMENTS

Graphic Facilitation in these two meetings involved a process of teaching the group what they needed in order for them to actively participate in and govern their own community programs. Here, the

power of Graphic Facilitation was multi-fold: Because I was as much a student as the participants in the first mural, my learning on the spot through drawing and choosing metaphors provided a role model which helped deepen their engagement, their motivation to learn, and, ultimately, their understanding of the facilitators' concepts—as it did my own. Choices of metaphor were about simplifying difficult concepts.

In the first mural, I used a person (a gymnast) to symbolize a larger program and to make it understandable to the workshop participants. In retrospect, I wonder how inclusive this metaphor was; gymnastics has been noted to be an expensive, mostly middle or upper class Caucasian sport.[2] However, at the highest competitive levels, the statistics show a mixed picture: On the 2009 U.S. national gymnastics team, for example, Hispanics are underrepresented when compared with the U.S. population by about half.[3] Blacks and whites are proportionately represented and Asians slightly overrepresented. While in many local low income communities, gymnastics may not be a popular sport, the group did respond well to the metaphor. It's possible that they liked it because of the personal connection with their fellow participants, a mother who was proud of her daughter's interest in gymnastics. *My point is to encourage Graphic Facilitators to consider their metaphors carefully: do they include or alienate group members? Can they identify with the metaphors?* Rather than making an assumption, which in itself could be the result of the Graphic Facilitator's or participants' bias, it is always best to check it out with the group. For example, assuming that this community couldn't relate to a gymnast might be a biased assumption. Would soccer or dance have been a better metaphor? Perhaps. In this case study, I, as the Graphic Facilitator, could have opened up a discussion about the inclusivity of the metaphor before deciding on it. This would have created a space for dissent or discomfort on anyone's part.

In the second mural, I chose a street scene with the family resource center at its hub to convey the accessibility of the data-gathering

2. http://gymnasticscoaching.com/new/2010/01gymnastics-a-sport-for-rich-white-kids/, retrieved June 29, 2011.
3. 2009 National Gymnastics Team = White–66.7%, Black–14.8%, Asian/Pacific Islander–11.1%, Hispanic–7.4%. United States as a whole in 2008 = White–65.6%, Black–12.8%, Asian/Pacific Islander–4.7%, Hispanic–15.4% (The Margin of Error includes Native Americans and those who check the "multi-racial" box) (US Census Bureau).

process. The importance of residents as essential to the success of the project was described by including figures drawn in the homes–participating and talking to other figures conducting the surveys. Participants in the workshop saw themselves becoming "real" on paper through their actions as the metaphors and imagery emerged and as it followed their thinking and suggestions. The underlying message of the workshop was "your opinion matters and you will help form and shape program design. *You matter* in this community." Through the workshop and the murals, participants became deeply certain of their abilities to shape their programs and, indeed, their futures.

In this Inclusive Governance Case Study, Graphic Facilitation was used to *teach* difficult concepts. Imagery not only carried the meaning of the ideas to participants, but gave the concepts *accessibility,* which enabled group members to understand and integrate these notions. Conveyed through words only in a "giving of information" format, the ideas would probably have remained distant, confusing, and mysterious–even perhaps meaningless. Using the visual depth and expansiveness of Graphic Facilitation, concepts could become interesting and *real* while they lost their confusion and so could be effectively applied. The facilitator and the Graphic Facilitator worked together to teach the process of evaluation to group participants. But it was the murals that allowed participants to *understand and make the ideas their own.* Therefore, they could move forward. Perhaps *all* education should consider this dual approach.

Chapter VII

CASE STUDY NO. 5.
BORDERS AND TIMELINES:
DEALING WITH CONFLICT

INTRODUCTION

In Case Study No. 5, "Borders and Timelines," I describe one meeting, or *teaming forum,* as the client liked to call it, to indicate their focus on building communication across teams. In preparation, I conducted a series of individual interviews with key players involved in this multi-year construction project.

During the process of each preliminary individual interview, I drew a small mural to document the interviewee's experience and perspective while working on the project. I then used this material to create a master timeline–a 14-foot-long wall mural–to provide a focus for the teaming forum dialogue. My role as a Graphic Facilitator spanned a two-month period.

I write about this project because of the complexities of working with clients who are in serious conflict and describe the lessons it provided. I discuss the final mural, Figure VII-1 and how I arrived at it. I also describe Figure VII-2, a detail of a draft version of the timeline mural. The purpose of sharing my experience on this project is to show how Graphic Facilitation can be a pseudo-therapeutic tool to bring resolution and understanding to situations where groups conflict. My act of drawing during the interviews, creating a master draft timeline of common themes, and then producing a final timeline functioned as a mediation process with the groups.

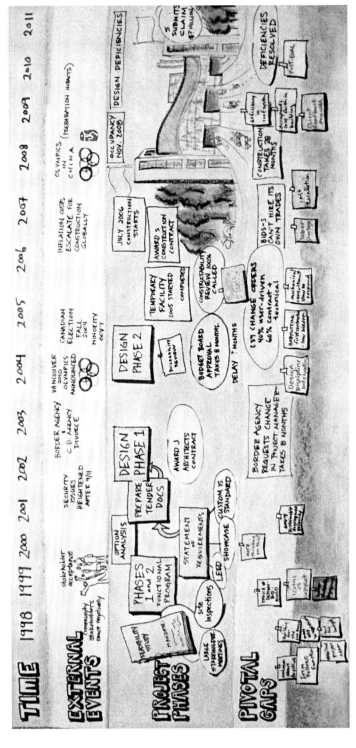

Figure VII-1. Borders and timeline. (Color version of this illustration can be viewed on the accompanying CD-ROM.)

BACKGROUND

The project was initiated by a large Canadian agency responsible for managing, building, and providing services at border crossing facilities between the United States and Canada. All names have been changed to maintain confidentiality. These fictitious names represent agencies in both the U.S. and Canada.

A construction agency (ConAg) was contracted by the Border Agency to manage the design and construction of the facility along the U.S./Canada border. This particular piece of the border was not highly traveled in comparison with those near large cities or airports, but traffic along it had grown substantially. About 1995, the Border Agency identified that their existing facility was too small to meet demands and not up to current building code standards. They needed more traffic lanes to reduce wait times for travelers and to improve the building for Border Agency staff and visitors. From initial design and construction of a temporary facility through design, construction and occupancy of the permanent facility, the project took about 15 years to complete.

Towards the end of construction, the Border Agency gave a very low assessment of the project in general and how it had been managed. They cited several examples such as specific design deficiencies, ConAg's lack of responsiveness along the way, inefficient processes, and unqualified ConAg workers. The overall satisfaction rating was among the lowest ConAg had ever received, at about 1.2 of a possible perfect rating of 10. The Border Agency's dissatisfaction with ConAg's work on the project was cause for surprise and alarm for ConAg. The Border Agency was a major client and ConAg depended on it for regular business—as it had done for decades. ConAg assumed the relationship would continue long into the future and had counted on it. The Border Agency had hired ConAg every year for many millions of dollars of construction projects nationally. But the level of dissatisfaction about the current project was a clear threat to future business relations between these two agencies.

CLIENT

ConAg talked with the Border Agency about hosting a teaming forum to address the concerns raised in the report. Wisely, ConAg

wanted to rebuild trust and confidence with their client, and thought that sponsoring a day-long collaborative event might be a good place to start.

REQUEST

ConAg's public relations manager called to ask for help soon after she learned of the low satisfaction rating. They wanted my team (a seasoned management consultant and I), whom they had worked with before, to facilitate the teaming forum. The Border Agency, they said, was to be treated as an equal player and client throughout the project. To underscore this collaboration, the consulting contract (also called "Terms of Reference") would be written by both agencies and both agencies would agree on the contract and sign it. The two agencies would have equal input into designing the teaming process event. Two lead representatives from each agency were designated to work with the facilitators to formulate the process. Our "client" for the purpose of this case study was now both organizations.

ConAg, partnered with the Border Agency to agree upon the agenda for the teaming forum. Its purpose was to enable a discussion of the successes and challenges of the border crossing project and to establish future implications for a continuing relationship. My colleague and I both acted as lead facilitators, although I took the Graphic Facilitator role.

FIRST MEETINGS WITH CLIENTS

I met with the public relations manager at ConAg to explore why they thought help was needed and what I could offer. The manager described a long and sometimes tumultuous relationship between the two organizations, now shakier than ever. The Border Agency was in the manager's portfolio of clients, but she had worked on this particular border crossing project for only a few years. Still, I was impressed with how much she knew about the project and the players, where she thought it had gone off track, and who was responsible. She was insightful and very likeable. If the rest of the team was as savvy, I thought, this assignment would be interesting.

Next, my colleague and I met with the ConAg manager and two key project leaders from the Border Agency. The meeting was scheduled at the Border Agency's main office, located in a city a few hundred miles from the proposed border crossing facility. Meeting on "their turf" was an important strategy. It sent a message of respect—*we will go out of our way to come to you*—and gave my colleague and me an opportunity to see the Border Agency's organizational culture. Their facility was inviting, with glossy photos and architectural models in the lobby. I felt their sense of pride in their work.

The ConAg manager introduced us and stated the purpose of the meeting. With a great deal of evident frustration, the two representatives from the Border Agency began describing details of the joint project. They talked rapidly about people, problems, and milestones we knew nothing about. This project seemed very personal to them. They said: "There are no gutters on the building! How could ConAg have missed that one!? ConAg delayed the project by months—sitting on change orders!" We knew we were clearly in the middle of a conflict between the two sides. We were confused by the content of the outburst, but not wanting to get bogged down, tried to bring some order to the discussion by asking questions about the teaming forum. "What do you hope to get out of it?" "What are your goals for the forum?" we queried. And then we listened.

To give focus and structure to the collaborative teaming forum, my colleague settled on Graphic Facilitation. It was proposed that I create a timeline in the form of a large wall mural, to mark important players and events across the 15-year project. To understand what went well and what didn't, data for the mural would be generated in individual interviews with key project managers, their supervisors, engineers, facilities workers, and architects. The Border Agency and ConAg clients seemed intrigued. They had never heard of Graphic Facilitation, but the proposal made sense to them when I explained the benefits. The list of interview participants was included in the contract and was sent to superiors of both ConAg and the Border Agency to review and sign. With this strategy the "higher ups" of both organizations were aware of and bought into the partnership process to come, where conflicts could be extensively aired and possibly resolved. Several weeks later, the interviews began.

INTERVIEWS

A ConAg project manager was interviewed first; he had created quite a bit of controversy for the project team during his tenure from 1999–2002. According to his teammates, he had a confrontive, prickly style interpersonally, although upon first impression, I found him quite likeable. The project manager's role was liaising with the Border Agency to make sure they were getting a building that met their needs. He also managed the architect and contractors to ensure the project was done according to specifications. On a $100 million project, this was an important and complicated task.

The interview began with a "conversation guide" designed by the facilitators with approval from the client team. It outlined questions to be answered during each interview, such as, "What milestones stand out for you over the span of the project?", "What external events impacted the project?", "What challenges did you encounter on the project (processes, personnel, communication, culture, organizational)?", "What went well?", and "What were the 'elephants in the room' that were never discussed?" I knew from experience that less formality was preferable, so I often used humor at the beginning of each interview to relax interviewees. It was important for each individual to share what was important to them, not simply the "facts." Much as an art therapist might explain the process of art-making in a first session with a client, I explained that I was going to draw what I heard from them on the whiteboard during our time together. I would photograph it, and bring it back to my studio later to use it to create a draft timeline for the teaming forum event.

The first interviewee avoided the conversation guide questions altogether. He was anxious to talk about his experience in his own way. Although he had been removed from the project many years previous, his strong feelings were still very close to the surface. Hearing his emotional venting, I had to remind myself that this wasn't art therapy but an information-gathering meeting. An additional priority of the interview was my building enough of a relationship with the interviewee in order to gather the nuances of how the conflicts had developed. I stood up and started drawing on the whiteboard. I drew a line across the middle from left to right and explained that I wanted *his* timeline, *his* experience on this project.

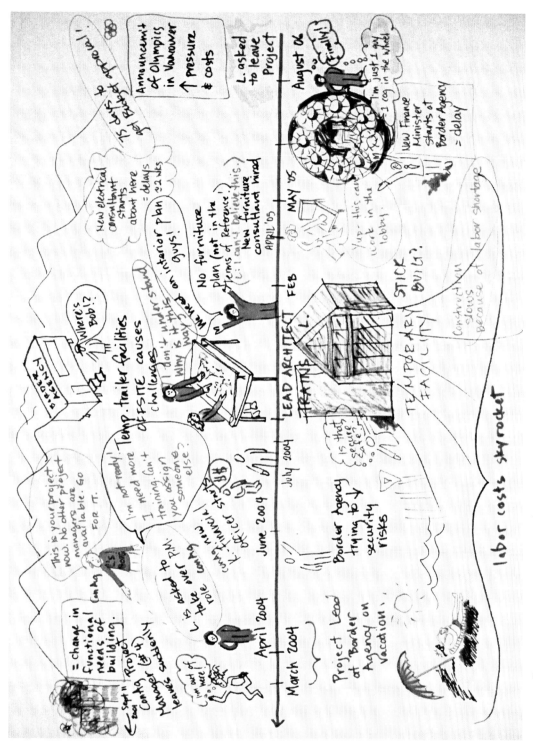

Figure VII-2. Timeline draft. (Color version of this illustration can be viewed on the accompanying CD-ROM.)

I started noting some of the months and years mentioned by the interviewee: when he was assigned to the project, what was happening with design and construction at that time, and who he described as the critical players:

> My boss dropped this project in my lap when the project manager before me left the agency suddenly. I didn't get to talk with him about it, or get any direction. I wasn't experienced enough for such a complicated project, and I told my boss I didn't want the role. There was no one else available at the time, so I was assigned to it anyway.

The interviewee told us he learned as he went along, and heavily depended on the lead architect, an external consultant, for guidance. With his boss unavailable to answer questions, he was very aware of his own limitations. He expressed empathy for what must have been the Border Agency's feelings of frustration with his lack of expertise.

In subsequent interviews, we learned that the Border Agency management indeed was very angry with his lack of skill, and that they had been billed for time the architect worked to train him. They had repeatedly asked ConAg to have the interviewee replaced with someone more knowledgeable, but that took almost a year to accomplish.

I continued drawing the timeline with dates, names, events, and challenges, asking clarifying questions while I drew. Hundreds of people were involved in the project from contractors, to architects and engineers in the private sector and government agencies; I was just beginning to grasp the immense scope of the project. The drawing helped me understand the project and make connections–it guided the conversation. As I was drawing, the interviewee got up a couple of times and pointed to parts of the drawing to emphasize or make corrections to my pictures. The graphics intrigued him. His face got brighter when I captured his ideas on the board. Some of my figures looked like cartoons of his co-workers, which made him laugh.

By the end of the interview he seemed lighter, as if unburdened by a weight he had carried for a long time. I suspect the interview had been therapeutic for him. He said he felt like the whiteboard drawing made things clearer and allowed him to see the project from a broader perspective. Through the drawing, he saw the significance of his contribution. At the same time, the Graphic Facilitation process revealed the enormity of the project's scope. The whiteboard was cov-

ered with the names of a dozen project managers, dozens of consultants and contractors, engineers, and financial officers.

There were several significant external events co-occurring during the time he worked on the project, such as the attack on the twin towers in New York City on September 11, 2001; federal and local elections; and the announcement of the Winter Olympics in Canada. These events impacted the project by globally raising construction costs and altering security issues throughout North America. Through Graphic Facilitation, the interviewee was able to see that he was a small cog in a very large wheel and that there were many complex forces over which he had no control. While he may have contributed to problems on the project, much of it was beyond his or anyone's abilities to shape. I believe he felt relief for the first time in years regarding his role on the project. His body relaxed in the chair, his demeanor shifted from defensive to open. He stayed two hours with us instead of the one hour we had scheduled. My co-facilitator and I spent the next few weeks completing the other interviews.

Synthesizing Information

Next, I began to synthesize information from individual interviews to create a *timeline draft* for the teaming forum. Back at my studio, I spread photos of each individual timeline around my studio walls. Rereading the accompanying notes as I went along, I tried to consolidate trends and themes. I was struck by how profoundly the external events influenced the project. The attack on the twin towers, for example, instigated many new problems for the creators of this border facility project: Post-9/11, the open atrium lobby in the building design seemed less of a good idea. With an open design, pepper-spray, if released, would spread to innocent bystanders and staff throughout the building. The announcement of the Olympics in Canada, and later, the summer games in China, caused escalation in construction costs due to demand for workers and materials, making project timelines impossible to maintain. Most interviewees took on more than their share of personal responsibility for the impact of these events on the project. Graphic Facilitation helped them put the locus of control back where it belonged and off their shoulders.

I placed a subtitle, "External Events," at the top left of the mural– a first draft timeline. I divided the 48-inch-high page into six sections

top to bottom, to organize the six major themes. Under external events, I wrote the years from 1995 (left to right) ending at the present year. Under this section, I drew a section for "Players" I color-coded the figures and names by organization: I used a green marker to represent all the players from ConAg, a blue marker for the Border Agency, and purple for private contractors and others. Below this section, I drew the phases of the project from functional review at far left to feasibility studies, constructability, project design stages, and construction to 33 percent finished, through to the time when staff actually occupied the building. Problems and successes related to building were drawn in this section. Under this I drew a section called "ConAg Process Gaps," with another section below for the "Border Agency Process Gaps."

Problems with the Draft Mural

These two sections focused on inherent organizational processes that might impact future projects negatively, as they had with this border facility project. The draft mural was about 10 feet long, roughly drawn, with attention to content rather than aesthetic appeal. I sent an electronic photo to the four lead client representatives. The following day, I got a phone call from the public relations manager of ConAg, saying that they had just met with the Border Agency Assistant Director and the Project Lead, and that they all had serious concerns about the mural. "They really don't like the twin towers drawing" (see Figure VII-4).

The image was certainly stunning as was the original occurrence whether viewed in person or on TV, where it was repeated over and over again. I had drawn two towers in thick black marker, with an airplane flying dangerously close, about to crash into the right tower. Smoke and flames came out of the towers and the airplane. "Help!" is written across the top in small letters. Bottom left, I wrote "Security heightened after 9/11" and highlighted this in yellow. Every interviewee had spoken about the impact of this event on the project.

While I was aware that 9/11 was an emotional event for many people, I was surprised at the strength of the clients' reaction to the image, nearly ten years later. I had not anticipated it. I had hit a nerve. As an art therapist, I am aware of the confrontive possibilities and dangers of concrete imagery, but for a Graphic Facilitator, it is, of course, chal-

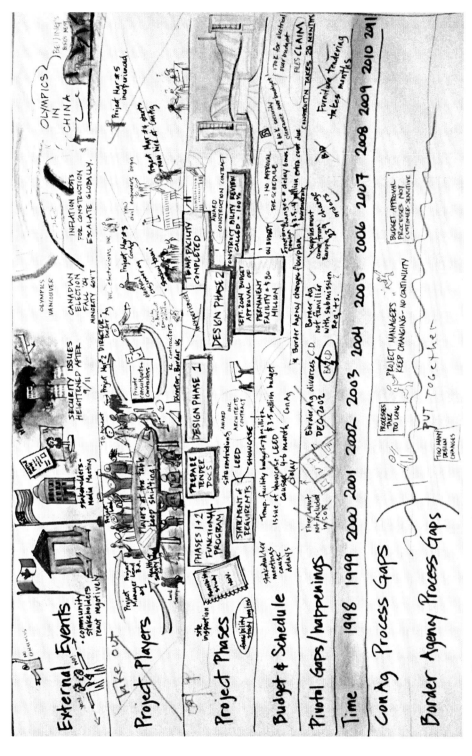

Figure VII-3. Process gaps. (Color version of this illustration can be viewed on the accompanying CD-ROM.)

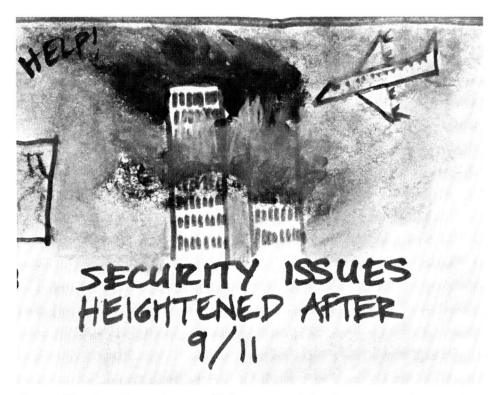

Figure VII-4. Twin Towers burning. (Color version of this illustration can be viewed on the accompanying CD-ROM.)

lenging to know that the client doesn't like your imagery. When faced with this situation, it is important how the Graphic Facilitator negotiates the resolution of the conflict with the client. Maintaining some personal detachment from the image itself is usually necessary. It is important to remember that the image essentially comes from the group, not the Graphic Facilitator "artist" and it is theirs to manipulate and work out. In this case, I had to weigh the opinions of the client with what I had heard from the interviewees. I likely would have handled it differently, in a less conciliatory manner, if I was conducting a therapy session. The tension was about deciding whether to reinforce what the client wanted versus confronting their processes and their denial. This is a delicate balance in Graphic Facilitation as in art therapy.

The public relations manager continued: "We may need to ditch the whole mural." "Why?" I asked. "It hits too close to home," she replied. "We don't want to draw attention to 9/11." Her fear appeared to

be a foreshadowing of the meeting to come and I sensed her anxiety about the upcoming teaming forum. It was the public relations manager's job to take her client's concerns about the mural seriously, and to let me know how I should fix them. I imagined she was experiencing some disappointment that her client, the Border Agency, was upset. I suspected her confidence in me was at stake as well.

While recognizing the underlying and on-going reality of the emotional impact of the 9/11 image, I tried to move forward in a rational manner. I asked specifically what was problematic. By the end of the phone call, the public relations manager was still insisting, "You have to take out the 9/11 drawing." The teaming forum event was only a week away, so I was feeling quite nervous. I suggested we meet in person to plan the teaming forum, and that we put the mural issue on hold until then. I agreed to remove the twin towers image.

My co-facilitator and I arranged to go to ConAg's office to meet with the people from the Border Agency. We brought the draft mural with the twin towers image cut out of it. (I literally took a sharp knife and cut the image out of the mural.) The new six-inch hole in the mural seemed symbolic to me of what 9/11 had come to mean. "Ground Zero," the name given to the hole in the ground where the towers used to stand, was a void symbolic of the anguish and grief for many lives forever changed or lost. It also marked the beginning of an era of increased security pressures on borders, particularly in the United States. The image I drew of 9/11 was too emotionally powerful for my clients. "We're kind of like firemen," a Border Agency man said. "We customs and border guys are in it together. We're still sensitive to what happened on 9/11" (and they didn't want to be reminded of the horror).

We knew we were in danger of dumping the whole mural as we started the meeting. My co-facilitator and I talked openly about the purpose of the mural. We recalled to our clients how we had come up with the idea together. We suggested that the timeline mural was worth keeping. We told them that the mural would provide visual support to help the group stay focused. I asked them to try and describe what they didn't like about the mural along with the 9/11 detail: "There are too many pictures, too many words, it's too overwhelming. How will the group be able to make sense of it?" Questions about the purpose of the mural were again expressed. "How could it be helpful in the meeting," they queried? With escalating anxiety, they finally asked if

the timeline could be produced in a more standard computer format, one more familiar to everybody and easier to read.

A Resolution of Sorts

As clients' fears expanded, I knew that it would take some effort to assure them that the mural timeline was indeed a critical tool. Countering their fears with my calmness as I might in an art therapy session, I described how I could alter the mural to address their concerns. I suggested we simplify it by deciding together what details should be removed. I offered to redraw the mural twice as large, with less information and with cleaner lines. The danger here that the Graphic Facilitator may assume narcissistic "ownership" of the mural as would an artist, and therefore, may have problems changing it, was overcome through the essential recognition that the mural "was owned" by the client.

I knew I needed the client representatives buy-in if the teaming forum was going to have a mural; their involvement in the process would be crucial. I handed out markers and asked them to stand up and come to the mural, which was hanging on the boardroom wall. "Please use the markers to stroke out everything you would like removed from the final timeline." After some cajoling, they cooperated, and actually started to have fun. Attendees talked with me and with each other as they worked. Looking at the "External Events" section, one asked, "Why don't we move this section over here?" (pointing to a segment higher up on the draft timeline). "Let's take out all of the players; we don't want to name names. Let's put the two agencies' processes together in one section." They consulted each other about the mural alterations in a friendly way.

Twenty minutes later, we had a revised timeline mural, but, importantly, now it was *co-created* by the clients and by me as Graphic Facilitator. The interview data was still included, albeit with some changes. It seemed workable now to all, and was something the clients could accept. Although they couldn't visualize the final product, I could. I took a deep breath when I realized that together we had made it through the potential morass of tossing-the-baby-out-with-the-bathwater. My impromptu exercise of inviting them to directly participate in defining the mural helped clients contain their anxiety, and gave them some power. It was a mini-teaming forum of sorts, much like a family

art therapy session where sometimes clients (children and/or parents/caregivers) may project onto the therapist. Was this what had happened with this mural? When the therapist is able to reflect back skilfully, through an art directive, the family can regroup in a new way, often realigning based on their discovery. That's what it felt like for me with this group. They projected their anxiety onto me, and when I gently reflected it back by giving them the opportunity to take control, they welcomed it and were able to continue on.

EVENT

My co-facilitator and I asked that the event be held on neutral terrain so that the group was away from their own environments. ConAg booked a boardroom in a renovated old heritage building with a modern sound system and projector. The goal was to maximize the opportunity for creative big-picture thinking about future relationship dynamics rather than blaming each other for project errors. The group size was 16, all of whom we had interviewed except for the recorder, the Assistant Director of the Border Agency, and the Director of ConAg, who had flown in for the event. We had strongly encouraged an interview with the Director of ConAg, but, unfortunately, he did not make himself available. Nonetheless, we knew his presence was critical in demonstrating to the Border Agency how much ConAg valued their business, and how much he personally wanted to heal the rupture in trust caused by this project.

We opened up the day with introductions, an amusing ice breaker, and warm words of welcome from the directors of the two agencies. Openly, they both spoke about their commitment to honesty, self-reflection, and compromise during this teaming session. They set a tone of personal responsibility by describing their willingness to own gaps within their agencies. These comments did more good than we could have hoped as they set the stage for a productive dialogue.

DESCRIPTION AND PROCESS OF THE MURAL

We then quickly moved to present the timeline mural which covered much of the side wall of the room (see Figure VII-1). I had

mounted it well before people arrived in the morning. Some of them had spent time looking at it when they arrived as they sipped coffee and greeted each other.

I Describe the Timeline and Encounter the Group's Appreciation for their Own Efforts

I guided the group slowly through the mural. I carefully described the interview process. My intention here was to refresh individual memories of the interview experience, and to apprise the Director of ConAg and a few others about the nature of the interview preparation. I explained that much of the detail they provided me was *not* on the mural. "Today's job involves bringing up your biggest concerns with everyone present, so we can dialogue about it," I suggested. "You can decide what details belong on the mural as a group." Although I had the urge to explain that the draft mural had been much richer in detail before last week's "butchering" session, I knew this wouldn't further the process, so I held my tongue.

After walking them through the mural, I asked each person to take four or five large post-its (3″x5″ colored paper with sticky backing) from the tables (markers and post-its were provided) and write what they thought was missing and still needed to be included on the time-line. Post-its were placed on the mural where group members felt they belonged chronologically speaking from left-to-right, and in which section top-to-bottom (Figure VII-1).

Influence of the Director of the Border Agency

The group was silent as they wrote and appeared energized by the post-it assignment. The Director of the Border Agency broke the silence by asking a question. The group tried to help him. He handed me his post-it; I held it close to the mural and made eye contact with him as he talked with the group and with me. He gestured with his hands to indicate where I should place the post-it, nonverbally asking me to place the post-it. I eagerly supported his request because I wanted to honor and encourage the messages he was now indirectly giving the group. He was saying, "Let's talk openly and honestly about our questions and concerns here today." This open interchange with the group set a strong precedent. The Director's willingness to engage

with the group encouraged them and helped them feel safe in his presence. From then on, each person spoke up freely about what they had written and how they felt about the project.

The dialogue evolved into conversations about *what was missing from the mural,* and how the project in general could have been improved. In the end, I realized that paring down my draft timeline to the basics was what the group needed: Paring down forced them to flesh it out and to openly raise concerns in front of their colleagues whom they had sometimes secretly thought of as oppressors. In part, this was made possible by the experience and relationship-building created through the individual interviews. As in art therapy, interest in their views and perspectives within a nonjudgmental atmosphere encouraged a developing relationship with the two facilitators which then carried through to the larger group meeting. As an art therapist often conducts an individual interview to assess, create relationship, and prepare a client for a group, here group participants arrived at the teaming forum event stronger, more open and willing to relate to the facilitators and each other because of the nuances of the preliminary interview. As the event began, they already were deeply embedded in a resolution process.

Working Together on the Mural
Encourages a Resolution Process

Over the next couple of hours, rather than remaining two separate organizations, the group grew together and became "one." Specific words and images on the mural and the post-its weren't important; learning to talk with each other was. They appreciated each other's contributions to the successes of the project, but were also able to openly argue about the challenges. That both Directors came to the meeting exemplified the value given to the event and provided the dialogue between the two organizations a level of credence that might otherwise not have been there. Rather than blaming, *a model of taking responsibility was illustrated.*

One of the lead Project Managers on the Border Agency remarked to me at a break, "This the first time I've *ever* met the Director of ConAg after all these years." He was glad to have the opportunity now, but the lack of client engagement on ConAg's part was obviously a major mistake. The teaming forum seemed to create a new beginning.

The day ended well: the group developed an action plan for how they would improve communication and organizational protocols on future projects and how they would work together in the future.

COMMENTS

Graphic Facilitation proved pivotal to a positive outcome for this group. Focusing on the mural timeline, group members spoke to each other about it instead of arguing with each other about past mistakes and wrongs. Later, group members expressed pleasure at the value of the timeline and the dialogue surrounding why to remove the imagery of 9/11.

My training and skills as an art psychotherapist were instrumental on this project. While there are certain limitations endemic to organization development work, my awareness of both organizations' psychological overtones was crucial as I chose how to move forward. When I first met the client, they knew they needed to work through the many conflicts between agencies, but they had little idea how to go about it. I listened carefully to their assessment of the problems, and together we came up with a plan. Moving into the interviews, my art therapy skills guided me. I built rapport with the interviewee as I would with any client in therapy. The added element of Graphic Facilitation was not unlike an art therapy project. The client did not make the art but guided my art work with their words, emotions, and sometimes by literally coming up to the whiteboard and pointing to parts of the drawing. Like art in a therapy session, it became a focal point through which interviewer and interviewee connected. With this connection, we were able to explore elements of the "problem" that would not have been possible without the graphics.

At first, in the draft timeline, I overwhelmed participants with too much content, too many images, and the picture of 9/11 which proved intimidating. Still, the 9/11 detail was an important part of the process because it provided something overt to react to, to react against, and finally, something *to reject*. The 9/11 detail never made it back into the mural.

The Directors' presence provided value and legitimacy to the teaming event. Through the Border Agency Director's post-it interaction with the mural and with me, he made clear to group members

that it was safe to state their feelings and proposals honestly. They came into the negotiation process because the post-it exercise handed them control of the mural's content. The group's active involvement "editing" the mural helped assuage doubts about the Graphic Facilitation process, and brought members back into the driver's seat.

The title of this Case Study, "Borders and Timelines," is a pun on the metaphor of "Borders." A border is a line separating geographical regions or political divisions. Most of us feel elation when we get a stamp in our passport, clear customs, and gain entry into another country or return to our own home. But crossing a border also implies that things will be different, difficult, and "foreign" on the other side. Perhaps even the language will be different and, for one who does not speak it, threatening. Border crossings can be fraught with challenges and conflict for many people, paralleling the process between the Border Agency and ConAg on this project. Through Graphic Facilitation, the two neighboring agencies worked across borders, through their conflicts, setting limits and boundaries along the way. The final piece enabled the participating agencies to effectively work together, as in its entirety the mural became a symbol of collaboration and pride for both.

Chapter VIII

OTHER VOICES, LITERATURE:
THEORY AND PRACTICE

INTRODUCTION

This literature chapter includes what there is and it isn't much. But we have conducted a broad enough search to feel confident that we have touched on what there is. We include the few relevant published works in art therapy and, using personal communication networks, also include art therapists who, while perhaps not publishing, ventured into business and organizational consulting. An example is art therapy pioneer, Robert Ault, who, beginning in the 1980s and for 12 years was a team member in the Menninger Management Institute Program at the Menninger Foundation in Topeka, Kansas.[1] Ideas of iconography, visual thinking, definitions of interpretation and metaphor are described as a possible theoretical basis for Graphic Facilitation which, so far, has little if any theory or analysis.

Although not specifically Graphic Facilitation, the internet web presence of "Visual Practitioners" has been vibrant and growing in the last years. New media, blogs, online articles, online social media and websites are good resources and offer various applications pertaining to Graphic Facilitation. Practitioners from diverse backgrounds in both business and the arts are experimenting with the underlying theory of *using imagery as language for new understanding and innovation.* It is obvi-

1. Menninger Clinic and Foundation was founded in the 1920s. It was one of the first milieu therapy programs in the United States. Based on psychodynamic and psychoanalytic theory, from its beginnings, it had "activities therapies" including art and music and its founders were quite interested in art. Robert Ault was employed at Menningers for 32 years. He established a large art therapy program which trained many art therapists.

ous that the skills of art therapists in Graphic Facilitation can be a particularly exciting resource.

Sections in this literature chapter are Art Therapy, Business and Organizations; Theories and Ideas: Visual Thinking, Iconography, Interpretation and Metaphor; Visual Practitioners; Information Graphics; Graphic Novels; and Internet and Websites. This diverse and idiosyncratic collection of literature is meant to place the new field of Graphic Facilitation in a context to give the reader a "feel" for what might be useful. We also believe that the Graphic Facilitator must have background in organizational development. A selection of classic books describing this growing field are listed (with asterisks) in the References and Bibliography section, but are not discussed here.

ART THERAPY, BUSINESS, AND ORGANIZATIONS

As mentioned before, literature combining art therapy and business is virtually non-existent. However, Robert Ault (1983, 1986), recognized among art therapists as a pioneer founding member of the field and the second president of the American Art Therapy Association (AATA), as a member at the Menninger Foundation's Management Institute, presented a paper at the 14th Annual AATA Conference called "Art Therapy in the Business World–Exploratory Studies (Junge & Wadeson 2006, Junge 2010). He published "Draw on New Lines of Communication" (1986) in *Personnel Journal* where he described his work with the Management Institute.

Ault enjoyed giving presentations about corporate and business art therapy. His style was informal, warm, and chatty. But he hated to write, did not think it a strength, and, unfortunately, did not publish much of his organizational work (L. Schmanke, personal communication, 2009). His notes and papers are part of the Robert E. Ault Archives of the American Art Therapy Association at Emporia University, Kansas.

In the 1960s, Tobe Reisel, an art therapist from California, began many years of presenting workshops at National Training Labs (NTL). NTL's training or "T" groups (which in the 1960s leaned heavily on sensitivity style training groups) were first innovated in 1947 and have been a major influence in modern corporate training. Founders of NTL were Ron Lippitt, Lee Bradford, and Ken Benne. A "T" group is

learning through experience rather than through lecture and reading. It is known as "applied behavioral science." Among others, Reisel facilitated groups with Sherman Kingsbury, who was a prominent organizational leader and writer. Integrating art and creative processes with an organization development model in groups with a business population, Reisel is an important precursor of Graphic Facilitation.

Generally, the art therapy work there is tends to be single workshop, individual, and psychodynamically based, and does not arise from systems theory. An example is the study by Turner and Clark-Schock (1990). They made a foray into corporate work in the late 1980s and their paper, "Dynamic Corporate Training for Women: A Creative Arts Therapies Approach," was published in *The Arts in Psychotherapy* journal in 1990. The late 1980s and the 1990s was an era in the organizational literature and in feminism when the assumed qualities of women such as relationship skills were often pitted against the more aggressive assumed male qualities of men in management and it was argued that women would transform management and organizations. Sally Helgesen's 1990 bestseller *The Female Advantage: Women's Ways of Leadership* is an example of this genre.[2] Business management writer On its cover, Tom Peters called Helegesen's book "A first-rate piece of research. Men who wish to stay employed take heed!"

Turner and Clark-Schock (1990), intending to increase women's self-esteem and thus make them more effective, conducted workshops for corporate women exploring self-image, conditioning, and attitudes in the workplace. Indicative of the times, the female clients they wrote about were dealing with strong gender inequality at work and this was the authors' focus in their work with them. The article includes four case studies of corporate women participating in a workshop, and describes the process of art and movement-making as a means to increase self-esteem and effectiveness in their jobs. The case studies describe art created by individual women within the group workshop setting.

2. Despite Helgesen's claim of research, there was and IS little convincing research to support the assumptions of differing gender skills and this variety of literature from the 1990s seems decidedly out of date. While many women *have* been able to achieve considerable power in organizations, it is unclear that anything enabled this other than far-reaching opportunities emanating from an increased level of consciousness, goodwill, political pressure, and hard work. According to correspondents on the TV show "This Week/Cristiane Amanpour" (6/12/2011), there is good research to show that businesses with more women make more money. However, parity in business or in the United States Congress is still a long way off.

It is no surprise that the Turner and Clark-Schock article was published in an arts psychotherapy journal because it is an art and movement *therapy* approach with the specific population of corporate women. An important distinction in the Graphic Facilitation process of this book is that the Graphic Facilitator creates *a visual image of the group's thinking.* Raising self-esteem or other individual goals are not at issue. From a whole systems viewpoint, of importance is the corporate woman as a part of the organization. In organizational development, it is the Graphic Facilitator who holds the responsibility to translate and visually interpret what she or he hears and understands *for the benefit of the whole group.*

Bobbi Stoll has long been a proponent of alternative art therapy applications. In the 1990s, she worked as a consultant conducting team-building workshops for administrators. She presented a paper on this work called "Taking Art Therapy into the Workplace" at the 30th Annual American Art Therapy Association Conference (1999a). Stoll introduced art therapy into American Red Cross Disaster Response (1998, 1999b) and used art therapy in dozens of national disasters to diffuse and work with crises. She recalls using art therapy exercises in critical incidents at banks, factories, oil refineries, corporate offices, clinics, law offices, motion picture lots, and with traumatized employees following traumatic incidents in the workplace. She also dealt with bomb scares at the IRS and other federal building departments (B. Stoll, personal communication, 2011). Stoll's interventions primarily focused on the individual under stress and the impact of the devastating event on the individual and the organization. In her model, a participant creates artwork with the goal of using the various opportunities inherent in art to work on the traumatic results of the disaster experience. Wordy reports that few would read could be written, but this powerful approach—incorporating imagery into trauma management with people and organizations—created an important new visual statement and is a precursor of Graphic Facilitation.

Another form that art therapy integrated with organizational development has taken is to provide a nurturing physical environment for management and organizations' retreats. Ellen Speert, a San Diego, California art therapist, conducts retreats with management teams and staff of organizations to help with stress management, cohesion, and communication issues at her California Center for Creative Renewal

(www.artretreats.com). Then in 1992, Joan Bosky, graduate student at Loyola Marymount University in Los Angeles, for her Master's Thesis wrote about art therapy and organizations. Working with Professor Maxine Junge, one of this book's authors, Bosky researched "Creative Organizational Consultation by an Art Therapist." She claimed that while art has been used in workshops, to that date, "no fully developed exploration has ever been attempted . . . which uses art through the various developmental states of organization (p. iv). Bosky wrote: "I hope this work will encourage art therapists to expand their expertise beyond the practitioner role and to apply their skills of psychological understanding within a creative context to a wide range of settings" (p. iv). As far as we know, unfortunately, Bosky's wish has not yet come true.

In the late 1980s, Maxine Borowsky Junge worked with a wide variety of the integration of art and organizations. In one instance, she created reflective visual art during a workshop facilitated by renowned organizational consultant Dr. Charles Seashore, who wrote the Foreword to this book. Michelle Winkel, the other author maintains a Graphic Facilitation consulting firm, "Unfolding Solutions."

THEORIES AND IDEAS: VISUAL THINKING, ICONOGRAPHY, INTERPRETATION, AND METAPHOR

This section contains a selection of literature we consider relevant to Graphic Facilitation. Obviously, this is not a complete rendering of the visual arts, organizational and psychology literature that might provide a basis for the work in this book. But here, we offer the reader a brief description of some of the literature we have found useful in placing the origins of the Graphic Facilitation idea.

Visual Thinking

Rudolph Arnheim's (1904–2007)[3] *Visual Thinking* published in 1969 (1969a), provides the tremendously influential integration of psychology and the arts. Arnheim was born in Berlin and received his

3. Biographical information about Arnheim is culled from en.wikipedia.org/wiki/Rudolph _Arnheim, retrieved June 11, 2011.

doctorate at the University of Berlin. There he studied with Gestalt psychologists. One of these was Kurt Lewin, who later was a leader at the National Training Labs (NTL) in the United States and was Arnheim's academic advisor. The Gestalt Psychology experiments in *Visual Thinking* have been very impactful on organization life and theory, and Gestalt psychology theory is intrinsic to many organizational development educational programs.

In *Visual Thinking,* Arnheim finds the paradigm which separates seeing and thinking and perceiving and reasoning to be false. A Gestalt psychologist, he proposes a holistic manner of approach and espouses the need to educate the visual sense. *Art and Visual Perception* (1969b) is perhaps the most widely known of Arnheim's works and has been called one of the most influential books of the twentieth century. A Jew, Arnheim left Germany and immigrated to the U.S. in 1940. He was a professor at Sara Lawrence College, Harvard College, and the University of Michigan.

Jean Gebser's (1985) *The Ever-Present Origin* is a magnificent history of the development of culture and consciousness through its arts. It is not an easy book to read but is well worth the effort. Originally in German, it offers fascinating ideas and scholarship about the intertwining of art, culture, and consciousness potentially relevant to the Graphic Facilitator.

Tony Buzan (1996) is an educational consultant who in the 1960s invented the concept of "Mind Mapping" from theories about how the human brain works. The intention of "Mind Maps" is to represent information in a visual format, similar to the way the brain itself maps concepts–a nonlinear, interconnected method. According to Buzan, Mind Maps use color, images, and symbols to help stimulate the brain's recall. Buzan authored and co-authored over 100 books related to learning, memory, and maximizing the use of the brain (www .thinkbuzan.com). In 2006, he launched his own software program to support his trademarked concept of *Mind Mapping* called *iMindMap.* Buzan's work has influenced businesses and opened them to alternative methods of learning, note-taking, and conveying information. His website is www.open.ac.uk/infoskills-researchers/developing–mind-mapping.htm. One could argue that Buzan is really a visual practitioner, but since Mind Maps are ostensibly based on the processes of the brain, we have chosen to place his work in the "Theories" section.

Iconography

Mitchell (1986) wrote the seminal book *Iconology: Image, Text, Ideology.* In it he describes the nature of an image and differences between words and images. From the Greek, meaning "image-writing," *iconography,* is the imagery or symbolism of a work of art, an artist or a body of art.[4] Taking it to another level, iconology or the study of icons or artistic symbolism[5] examines the symbols *within a political and historical context,* exploring the relationship between words and images. Mitchell (1986) proposes "to show how the notion of imagery serves as a kind of relay connecting theories of art, language, and the mind with conceptions of social, cultural, and political value" (p. 10). Discussing a variety of theorists, Mitchell explores imagery in relation to concepts of imagining, perceiving, resembling, and imitating theorists.

In 1995, Mitchell published *Picture Theory: Essays on Verbal and Visual Representation* in which he expanded on his ideas and asserted that images are in essence living beings. Mitchell's work informs the Graphic Facilitator as they listen to the group and make decisions on images and words to translate and portray in the mural. Mitchell's work helps inform a new theory for visual practitioners.

Robert Horn, in 1999, contributes to the discussion about the relationship between images and words in his book *Visual Language: Global Communication for the 21st Century.* Horn reflects that in current culture, we see the integration of text and words as never before through marketing, internet games, social media, and information graphics. He argues that when text alone doesn't suffice, *images* help express complex ideas. In his ideas about visual language, Horn's work provides a basis for Graphic Facilitation as well as art therapy, and even art itself.

Interpretation

"Interpretation" is defined by the dictionary as "an explanation of the meaning of another's artistic or creative work: an elucidation"[6] Since Freud and his *Interpretation of Dreams,* the concept of interpreta-

4. http://www/merriam-webster.com/dictionary/iconography, retrieved July 4, 2011.
5. http://www.merriam-webster.com/dictionary/iconology?show=0&1=1310437368, retrieved July 4, 2011.
6. http:[Merriam Webster] dictionary.reference.com/browse/interpretation, retrieved July 7, 2011.

tion has been a central tenet of psychodynamic psychotherapy. Langs (1982), in his *Psychotherapy, A Basic Text,* defines interpretation as "An attempt through verbal communication by the therapist to render unconscious meanings and functions conscious for the patient" (p. 729). Greenson (1967), in *The Technique and Practice of Psychoanalysis,* calls interpretation "the ultimate and decisive instrument. Every other procedure prepares for interpretation" (p. 39). Simplistically, it is the method through which the therapist verbally makes the unconscious conscious.

For an art therapist, the verbal becomes visual and often an art therapist may be asked to interpret a client's artwork. The two major art therapy theorists, Naumburg and Kramer, both caution against the loose usage of the term and of the practice, and a good art therapist knows that interpretation is a risky, subjective business. Kramer differentiates between the interpretation "of reality, of functioning and of unconscious meaning" and states: "Art therapy lends itself particularly well to the interpretation of functioning" (p. 37). She does not believe interpretation of artwork should *uncover,* but states it can create an awareness of reoccurring patterns of behavior. On the other hand, Naumburg writes: "The art therapist does not interpret the symbolic art expression of his[7] patient, but encourages the patient to discover for himself the meaning of his art productions" (p. 2).

Berger's *Ways of Seeing* (1972) is a classic. In seven essays, he combines the concept of *culture* with the visual and calls it *visual culture.* Discussing how culture impacts our *interpretation* of art, he emphasizes the *choice* of what to *interpret.* This reminds that the Graphic Facilitator is a *choice-maker.* From what he or she experiences and hears, the Graphic Facilitator creatively determines what the group is trying to say underneath the surface chatter to decide what will be most effective in the mural. Berger's work also points out to the Graphic Facilitator that those in the organizational event room are products of diverse cultures, so each participant will have a different way of seeing.

7. The sexist language of the day is retained in the quotation.

Metaphor

Definitions of metaphor vary wildly. Originally, they were considered a literary device using "an image, story or tangible thing to represent a less tangible thing or some intangible quality or idea."[8] (We remember that writer Cynthia Ozick defined them as a *bridge* between two contrasting ideas.) Although metaphor has long been part of traditional healing methods, in the last 30 years or so, mental health clinicians have been rediscovering their use in psychotherapy. Influential figures in modern metaphor use are Lakoff and Johnson (1980) and Milton Erickson (Haley, 1973; O'Hanlon 1993), famous as the originator of contemporary clinical hypnotherapy and an early family therapist who viewed much of human communication as metaphor. Neuro-linguistic programming, an influential therapeutic idea of the 1980s and 1990s, made extensive use of metaphor (Grinder & Bandler, 1981). For the reader who wants to learn more, Witzum, Van der Hart and Friedman's 1988 article, "The Use of Metaphor in Psychotherapy," is highly recommended. In it, they explore metaphor's linguistic structure toward the intention of offering clarity about content and clinical use.

In *Handbook of Art Therapy,* Riley and Malchiodi (2003) contribute a chapter on "Family Art Therapy." In a section called "The Use of Metaphors," they cite the beliefs of pioneer family therapist Jay Haley. He says: "Metaphors are analogies through which the therapist and client can communicate in a powerful, direct, but nonthreatening way. They can be visual, verbal or both" (Malchiodi, 2003, p. 363). Riley and Malchiodi emphasize that metaphors are useful in family art therapy because they evolve from the client and can be shaped by the therapist into a specific and suitable intervention.

Metaphor is one of the Graphic Facilitator's most important tools. It helps transform the musings of a group into something it can grab onto. Transforming a specific metaphor into an image grounds it and enables the group to make changes in the progression of the metaphor, as they might make changes in their organizational life. Although there is plenty of literature about the value of metaphor in literature, art, and even psychotherapy and art therapy, there is little that pertains to organizations and visual practice.

8. http://en.wikipedia.org/wiki/Metaphor, retrieved July 7, 2011.

VISUAL PRACTITIONERS

The term "visual practitioners" means those who use imagery to communicate. Although art in organizational work has been around for more than 30 years and organizational consulting as a practice has been on the rise in the late years of the twentieth century and the early years of the twenty-first, the process and procedures of Graphic Facilitation as outlined in this book are new. However, starting with Buzan in the 1960s, facilitators have been seeking complementary tools to support organizations through challenges and change.

Daniel Pink can be considered a precursor. In *A Whole New Mind: Why Right-Brainers Will Rule the Future* (2005), he writes about the shift from the information age to the conceptual age. According to Pink, right-brained attributes such as empathy, play, and meaning will have the greatest value in the new global marketplace. Although his work is really a polemic, Pink's background is politics and motivational speaking–he was the key speechwriter for Vice President Al Gore from 1995–1997–comes through in his perspectives, his convictions are a welcome change for right-brained visual practitioners.

David Sibbet (1991, 1994, 2002, 2010) is considered by many consultants to be the founder of visual practice in its current form. In 1977, he started The Grove Consultants International, a San Francisco-based leadership development, visioning, and organizational change company; Sibbet is its President. An example of his approach is the recently published *Visual Meetings: How Graphics, Sticky Notes and Idea Mapping Can Transform Group Productivity* (2010). Sibbet's book is a practical, witty guide for how to run better meetings and engage groups using graphics. Another example of his work is *Best Practices for Facilitation* (2002).

Sibbett comes from a journalism background, which may help explain his skill with language and his ability to strategically support challenged organizations. He describes how he stumbled across the power of visuals by jumping up to sketch his thoughts during a business meeting after college. The group responded eagerly. Compelled by the impact and power of the visual, he spent the next 40 years working with groups and experimenting with visual techniques as a means to enhance their collaborations. He and his organization produce websites and have become an excellent resource for consultants across the globe.

Nancy Margulies is another pioneer in the visual practice arena. A prolific writer and publisher, beginning in 1989 and sometimes with colleagues, she published books, comics, and videos that describe her techniques of applying graphics to organizational development work (1991, 1993, 1995; Margulies & Gelb, 1989; Margulies & Maal, 2001; Margulies & Valens, 2005; Maal, Wheatly, & Margulies, 2005).

Mapping Inner Space: Learning and Teaching Visual Mapping (Margulies & Maal, 2001) expands Buzan's mind-mapping concepts and techniques, in a practical how-to guide for students, teachers, and business leaders. Calling the work *"visual mapping,"* the authors include many colorful examples of these visual maps. With a philosophy much like that of art therapy, they are committed to the idea that everyone can draw and they write that the book is "an invitation to be creative while recording ideas" (p. 10).

A systems thinker, Margulies and her colleagues are very good at seeing the "big picture" in organizations. She also describes how-to tricks for creating visual maps with children. Her work most closely combines art therapy techniques with facilitation techniques and while it does not approach the trained art therapist's skills, the method presented here provides a good basis for Graphic Facilitation.

A recent addition to the literature is Daniel Roam's pamphlet *D. Roam's The Back of the Napkin: Solving Problems and Selling Ideas,* and the accompanying workbook *Unfolding the Napkin: The Hands-On Method for Solving Complex Problems with Simple Ideas* (2008, 2009). Roam's premise is that simple doodles on the back of napkins can solve problems. He uses stick figures to pare down problems and, in the second pamphlet, breaks down his problem-solving strategy in a step-by-step fashion. He does not place value in the aesthetics of the drawing itself but attempts to make the process encouraging and simple enough for the reader to grasp.

Workbooks to coach presenters, trainers, and teachers on how to improve their drawing and presentation techniques abound. They are not aesthetic, metaphorical imagery, nor do they pretend to be. They usually illustrate a *dictionary* of symbols that the practitioner can borrow from. When the facilitator masters these one-dimensional, simplified symbolic representations, they are potentially able to expand their graphic presentations past the merely verbal. Typically, the symbol is drawn with a black marker and is restricted to black and white. Many

of the symbols resemble cartoons. While this kind of information encourages the use of visual imagery in organizational work, in a sense, it simplifies the information rather than enriching it or representing its complexities. Ideally, the Graphic Facilitator presents images and metaphors that portray a depth and variety of complex ideas in an aesthetically compelling manner to impel dialogue to go forward.

A few of this type of workbook include Kearney's *Graphics for Presenters–Getting Your Ideas Across* (1996), Westcott and Landau's *A Picture's Worth 1,000 Words–A Workbook for Visual Communications* (1997), and Sonneman's *Beyond Words–A Guide to Drawing Out Ideas* (1997). These books provide straightforward tools for the novice Graphic Facilitator to practice lettering, color, line spacing, and basic symbol.

McGinn and Crowley's 2010 "Vision Statement: Tired of PowerPoint? Try This Instead," in the *Harvard Business Review,* highlights some benefits of using visuals to improve organizational productivity, and demonstrates the growing fascination with this field in the business world. Citing a study which measures how well visual representations boost memory recall, the authors relay a testimonial by a senior manager at Accenture, a large management consulting, technology, and outsourcing firm, who was delighted by the benefits graphic recording supplied at his meetings. A mural sample by visual practitioner Stephanie Crowley is included in the paper.

Life Coaches, often a current incarnation of psychotherapists, are ostensibly starting to incorporate visual imagery into their work with clients, bringing to full circle, art therapy notions of client-created artwork as a vehicle for growth.

INFORMATION GRAPHICS

Information graphics is a burgeoning field with new books being published monthly or more. At the core, it has some of the same intentions as art therapy or Graphic Facilitation–using imagery as a vehicle to communicate complex ideas for viewers. For example, students trying to make sense of statistics routinely use *Cartoon Guide to Statistics* by Gonick and Smith (1993). This was an early form of information graphics, or " infographics" as it often called. In infographics, the pictures present information, data, or knowledge in a visually clear way,

such as on a subway map.

Statistician, Yale professor, and sculptor Edward Tufte (1983, 1990, 1997, 2003a, 2003b, 2006) is often considered a pioneer in the field of data visualization and infographics (Yaffa, 2011). In 2006, *Business Week* magazine named him the "Galileo of graphics." He wrote many books and articles about ways to be visually effective in communicating data. In a 2003 *Wired* magazine article, "PowerPoint is Evil" (2003a), Tufte criticized "PowerPoint" as a crutch for presenters, rather than as an effective communication tool. His thinking has been widely influential for practitioners trying to communicate ideas graphically.

Nigel Holmes (with Reiter and Sandomir, 2007), former Graphics Director for *Time Magazine,* wrote *The Enlightened Bracketologist-Wordless Diagrams* about parsing decisions down to essentials. The work is called "explanation graphics" and deals with the visual display of information. For Graphic Facilitators, Holmes et al. can provide guidance and structure for making decisions about the selection of which information to visually represent when working with groups.

GRAPHIC NOVELS

Graphic novels are very interesting with respect to Graphic Facilitation work because they illustrate serious and complex ideas using ideas, drawings, and storylines. A graphic novel is a narrative work in which the story is conveyed to the reader using sequential art in either an experimental design or in a traditional comics format. Words and images are often deftly combined to convey strong ideas and emotion. Examples of good graphic novelists are Barron Storey, Kent Williams, and David Mack. Consultant Carl Wyckaert maintains a blog with some interesting graphic novel illustrations (www.graphicnovelart .blogspot.com). Some graphic novel artists/authors are very creative with small spaces–the frames of the comic strip for example, yet are able to capture complicated ideas: humor, anger, love, frustration. The novice Graphic Facilitator can learn about simplifying drawing, keeping it on task, fun, and relevant. The classic children's comic series *Adventures of Tintin* by Georges Remni (writing under the pen name "Herge") gained an international following soon after its first publication in 1929 (1930, 1986).

INTERNET AND WEBSITES

Blogs, online articles, social media, and websites–new computer-ized media–provide an important resource and a plethora of informa-tion for those interested in visual media and Graphic Facilitation prac-tice. The web presence of *visual practitioners* has been exploding in the last few years and is likely to continue to increase. The reader inter-ested in visual communication is strongly urged to make continuing use of the internet, which provides immediacy that books and pub-lished articles cannot approach. As the examples in this chapter sug-gest, there is growing interest in the field of visual communication and practitioners from diverse backgrounds are experimenting, discussing, and videoing their experiments to present on the internet.

From the basics of markers and paper to the use of technological media like computer tablets, the internet is quickly taking over the printed book as the best way to find out who's doing what in visual planning and visual communication arenas. In part, this may be the result of the early adoption of innovative, creative techniques by the technology sector in the early twenty-first century. Pioneers such as David Sibbett and his Grove International Consultants found much of their early business from the late 1980s, 1990s boom of dot.com com-panies. In addition, the digital medium was inherently a more visual one than books and journals. Far less costly and almost immediate to publish, the internet provides what traditional media cannot: a venue for a community of practitioners to share knowledge and ideas. Rather than being limited because of publishing costs to a few plates in a book, a click of the mouse can upload images to illuminate the com-mentary of an author. Perhaps because of its immediacy and because, so far, there are few limits and no formal institution to judge it, the writing can be academically less rigorous than traditional publications. Arguably, the goal of on-line, digital communications is different than traditional publications: The goal is not a one-way discourse as with any informational book, including this one, but the *sharing of the knowl-edge of the field,* with the *exchange* itself feeding the growth of the field and encouraging new practitioners and techniques.

Most of the authors we've mentioned have websites. Sibbet's site is www.DavidSibbet.com; it includes some of his talks (which can be lis-tened to online) articles, and lists of favorite books and websites. His

company's website, www.Grove.com, is equally resource rich and has useful templates for purchase for those presenters too nervous to tackle a blank piece of paper in front of a group.

Margulies' website (www.nancymargulies.com) describes her lengthy career in the visual planning field. Portfolio samples of her organizational development and visual planning work convey a more fluid artistic style than the slicker Grove style. Deirdre Crowley of Crowley & Co., the visual practitioner featured in the article by McGinn and Crowley (2010) "Vision Statement: Tired of PowerPoint? Try This Instead," discusses her service offerings at www.Crowley andco.us.

Other online communities in the areas of visual planning, thinking, and communicating are popping up globally. IFVP, the international forum for visual practitioners (www.ifvp.org) began in 2000, and is a nonprofit organization with a volunteer board. Its beginnings were in 1995 when Leslie Salmon-Zhu and Susan Kelly, San Francisco Bay area organizational consultants working as sole practitioners, wanted to connect with other graphics-minded folks to share their discoveries. Since then, the organization has grown steadily to about 100 members. As evidenced by the explosion of interest in the last decade, the forum seems to be effective in its mission of supporting and promoting visual practitioners and growing the field. It hosts an annual conference and shares ideas and information between conferences in an online forum. Michelle Winkel, an author of this book, is an IFVP member and also maintains a website with examples of Graphic Facilitation work at www.unfoldingsolutions.com.

Roam's website is www.DigitalRoam.com. He calls it "visual thinking for the business world" (2008). Blog articles related to visual communication are included, such as an entry describing a Delta Airlines flight attendant who essentially does a form of art therapy on the back of napkins to relax passengers (Roam, 2008).

Another wildly popular online resource is RSA animate (www .thersa.org), the animation series by the Royal Society for the Encouragement of Arts, Manufactures and Commerce based in Great Britain. This is a think tank of 27,000 members worldwide. The website features videos of lectures and debates by well-known Fellows, sometimes with accompanying illustrations to supplement the lecture. These videos show cartoon-like illustrations being drawn as an inter-

pretation of the lecture the viewer hears. The artist uses black and white marker with red thrown in for emphasis. The drawing is created in real time; the artist presumably listens to the lecture before-hand, comes up with a concept, and draws it out. The video speeds it up so it synchronizes with the words of the lecturer. While we find the illustrations aesthetically simplistic, some of the lectures are fascinating, and the illustrations make the audio more memorable. A United Kingdom-based firm called "cognitive media" creates the illustrations (www.cognitivemedia.com).

SUMMARY

This chapter contains an overview of literature pertinent to Graphic Facilitation. It includes Art Therapy, Business, and Organizations; Theories and Ideas: Visual Thinking; Iconography; Interpretation and Metaphor; Visual Practitioners; Information Graphics; Graphic Novels; Internet and Websites. What is currently published in art therapy has little relevance to Graphic Facilitation and, thus far, art therapists' published or presented explorations into the organizational arena have been virtually nonexistent. In the related fields of visual practice, some practitioners have been quick to recognize the immense potential of combining the visual with words, but most come from the corridors of business and do not understand the depths and complexities of the psychologies of organizations nor the inherent aesthetic opportunities. Typically, they do not have training as artists nor as art therapists.

Appendix C "Resources" contains websites which may appeal to the Graphic Facilitator. Websites of relevant professional organizations and visual practitioners are included.

Chapter IX

TRAINING FOR GRAPHIC FACILITATORS

This book is primarily for art therapists who wish to venture into business and organizational applications and this chapter on training is written specifically for art therapists. Nonetheless, there are people in the business and organizational arenas who are interested in using Graphic Facilitation in their practice. Although it is assumed that these practitioners will not have the art competencies and skills, nor perhaps the psychological knowledge that trained art therapists have, many of the guidelines in this chapter will pertain to them as well. A cautionary note is in order however: the use of art with organizations requires a depth of psychological understanding and is much more than the knowledge of a series of techniques. *It is most important that the practitioner not confident in art and psychology acquire this background and it takes time–at least two years.* It may be that a good Masters education in art therapy is the shortest route for an organizational development person who wants to use art in organizational practice.

DEVELOPING AND PRACTICING KEY SKILLS

Key Skill 1: The Artist in the Art Therapist

The art background of the typical art therapist can range from long years and training as a professional artist to a brief, but varied experience in media which serves as prerequisite for entry into many art therapy educational programs. In the first instance, an artist's identity is established and cherished, and the learning of art therapy becomes an expansion of that identity and practice. Most of the early pioneers of art therapy were of this sort (Junge, 2010). In the second instance, a

person often has a personal experience in which art–even the most primitive art–has the ability to self heal. They are fascinated and want to know more; they want to learn how to apply this gift given to them, to others. Some art therapists participate in art with their clients in art therapy sessions; most don't. The priority is *always aiding the client.* To be a good Graphic Facilitator requires that the art therapist step forward to be willing *to be* seen *as an artist.* This may not be as simple as it sounds, but it is crucial.

In a mural, the Graphic Facilitator documents the group's interactions. They create artwork in front of the group and the progress of the mural as it evolves is visible to all in the room. To be a Graphic Facilitator, the art therapist must be comfortable *to be seen as an artist* whose emerging artwork is viewed by others. The solitary artist who needs to create art in secret will not be able to adequately perform as a Graphic Facilitator. Graphic Facilitation is *a public process.* In a sense, the Graphic Facilitator must be enough of a "performer" or "exhibitionist" to enjoy the interactive process with group participants which enables the art to be seen and to be responded to. While the artist/art therapist does not need extensive technical prowess, she or he does need to be able to respond to what they hear by creating appealing imagery and metaphor, and be comfortable doing it directly and quickly. Different from art in art psychotherapy where primitive imagery can get the message across as in a means of communication, we have found over years of experimenting that visually compelling imagery *captures the group's imagination.* The aesthetic element is captivating; the more beautiful and complete the piece, the more attracted to and engaged the group appears to be. The textural and colorful quality of the chalk medium adds a level of depth that makes the mural accessible and inviting. Moreover, unlike art therapy, *it is the Graphic Facilitator who produces the art, not the client.* Following is a description of this necessary quality of the artist in the Graphic Facilitator:

> My first love was art. I started painting and building sculptures from scraps of wood in my father's garage when I was three or four. It's how I made sense of the world. It's how I felt good about myself. I love diving into the process, exploring materials and just seeing what happens.

The reader will notice that in some murals, there are many words. While clear, readable handwriting is not a requirement, it doesn't hurt. The evolution of artwork within a meeting is immediate work. The Graphic Facilitator creates directly, in real time in front of, and sometimes with, participants. *Written words within the artwork should be legible, aesthetic products.* Some people do this naturally; some do not. (For example, architects know how to make written language part of the aesthetic whole of the architectural vision.) If the fledgling Graphic Facilitator is one whose handwriting is not adequate, practicing will be in order. If this sounds a bit like elementary school-at least as it once was, so be it.

Key Skill 2: Articulate Dialogue

Graphic Facilitation is *not nonverbal.* Although the Graphic Facilitator documents through imagery, she or he will need a certain level of verbal articulateness in order to further a necessary dialogue with organizational participants (and, indeed, to include appropriate words within the visual context). This is another reason why the art psychotherapist who is used to exploring the visual product with words is closer to the "ideal" Graphic Facilitator than the art therapist who has focused on the healing properties of the creative process itself and may not have learned the skills of verbal exploration of the art product.

While a major portion of the documentation is visual in Graphic Facilitation, words are used in the murals; and the Graphic Facilitator must have enough understanding of the psychology and dynamics of the group as well as awareness of underlying and overt intentions of the employer/client to employ appropriate verbal and visual means.

Whether visual or verbal, the mural and the Graphic Facilitator become active participants in maneuvering the process along, interpreting it and guiding it through disruptions or downright decay. The Graphic Facilitator enables a visual and verbal *dialogue* through the art, to provide a depth of meaning impossible with mere words. In addition, the Graphic Facilitator incorporates words into the mural to enhance the depth of the dialogue.

Key Skill 3: Systems Thinking

To be an effective Graphic Facilitator, it is essential to master systems thinking. To put it simply, systems thinking is considering the

whole of something. It is a recognition that a whole is *more than the sum of its parts* and that it is the *relationships* between the parts that are essential. Most importantly, *systems thinking is a different way of thinking about change.*

A visual artist is aware that putting a color or shape into a painting changes the whole and he or she knows that the rest of the work may need to be changed in response. It then becomes an ongoing visual dialogue for the artist within the canvas as she or he creates it. The word "system" has become a regular part of our daily lexicon from beauty systems on. (A beauty system is products which require more than one product used in a proper relational sequence to create the whole effect. Check current TV advertisements.)

We live in a global universe in which communication systems, in an instant, speed information through whole countries; the *changing and resulting relationships* become crucial and may impact another country, even a continent, even the universe.

Nonetheless, to think about something *as a whole system* is not an easy matter for many. Despite Thomas Kuhn's 1964 arresting analysis of scientific paradigms which changed the way many people think about the world (*The Structure of Scientific Revolution*), the American way is still predominantly mired in the old theoretical paradox of cause and effect, linear thinking although Kuhn's important work is more than 45 years old. Concepts of "No Child Left Behind" currently driving the American educational system in which certain styles of teaching are desirable and lead to the outcome of better test scores in reading and math are examples of the prevalence of the old paradigm.

The authors of this book believe that most mental health training programs of whatever stripe and discipline still predominantly train therapists to think individually in their personality and developmental theories and in their treatment applications. Used often today, family therapy ostensibly relies on systems thinking and is taught in art therapy training programs. But many therapists continue their individual focus in the way they consider the case and how to help. They believe that by merely including family members of their client, they are doing family therapy; they are not. These practitioners are focused on the individual rather than the system with certain family members invited to contribute. Organization managers and consultants typically are better trained in systems thinking, in part because much of the

history of the organizational development profession was based in groups and their effectiveness.

Despite the permeable boundaries and obvious necessities of the global universe, America's dominant cultural paradigm is still individually based. Conquering untamed territory through the concept of manifest destiny is not really far behind us and is still an important thrust of current history. Always a major influence on United States development, the meta-message of most school systems is decidedly about individual problems, progress, and achievement.

It is not impossible for a person who thinks individually to expand to a systems approach. But it is not always easy and usually takes a deep desire to learn on the part of the student. A strong mentor whose métier is systems, who can help the novice acquire this new skill is necessary. This supervisor will need to step in when the student, quite naturally, reverts to his or her more comfortable habit of an individual theoretical bias. Finding such a mentor or supervisor will be discussed in a later section.

The following exercise is suggested to practice systems observations:

Make a descriptive statement about the dynamics of the group as a whole. The statement should be short–two lines at the most.

This is a snapshot at this particular time and place; it is not intended to be an established definition; it is known to be changeable, even minute to minute. The observer may have to start with more than two lines and work down, but eventually, she or he should be able to make a brief description of the whole. Where to find a group to practice on? The observer may be able to think of some in his or her own life, like a book club a group of friends, or she or he can look at groups and families on television. This exercise should be done over and over until the person is able to accomplish it with some facility and ease. It can also be done as a necessary "refresher."

Key Skill 4: Setting the Contract (Letter of Agreement)[1]

The contract is an agreement between the organization and the Graphic Facilitator that lays out in *writing* what is expected of the par-

1. The term "Letter of Agreement" is the same thing as a contract.

ties and how it is to be done. By necessity, it delineates the task quite specifically. The written contract should be signed by the consultant and by the client (or person representing the organization) and dated. Each participant should have a copy of the contract. It is the Graphic Facilitator's responsibility to provide the contract (Letter of Agreement). The Letter of Agreement should also spell out financial arrangements.

A Letter of Agreement is a familiar contract in organizations, although it may not be to an art therapist beginning to work with business groups. Sometimes the person in the meeting cannot sign the contract but must pass it on to his or her "boss" for a signature. But it is important to have a signed Letter of Agreement in hand before the Graphic Facilitator provides services.

A contract is a *legal* document and therefore we believe it is in the Graphic Facilitator's best interests to make sure it spells out the roles, goals, and expectations clearly. If the client only has a general ideal of what to include, the Graphic Facilitator can "negotiate" with the client in the first meeting to achieve particular items and issues to include in the contract. This negotiation can become a good base for the necessary discussion that the client might otherwise want to rush through.

Essential for the Graphic Facilitator contract is the handling and disposal of the artwork: Who "owns" it? Where is it kept? Can photographs be taken? What are the uses of the artwork?[2] We believe the Graphic Facilitator in his or her talk with the client, should bring a copy of a clean contract and go over it together with the client in the first meeting. (Appendix A is an example of a Graphic Facilitation Letter of Agreement or contract.)

Key Skill 5: Working as a Team with Another Facilitator

As a Graphic Facilitator, the art therapist will often work with another facilitator.

The dynamics of this dual facilitation should run smoothly and we believe that it is the Graphic Facilitator's responsibility to manage this relationship well. The other facilitator is often part of the organization

2. Later, if the Graphic Facilitator wants to use information or artwork from the event for a presentation or publication, should ask the Client to sign a specific permission form. Alert: Permissions are essential these days. To use material without specific permission may lead to legal entanglements and even lawsuits. Alternatively, the GF can copyright his or her work.

and works for the organization; she or he may lead the group, or give the keynote speech. An "internal consultant" may have a difficult time being effectively confrontive with the organization. The organizational person employs the art therapist as Graphic Facilitator and sets the terms, goals, and intentions for the contract. Essentially, the art therapist/Graphic Facilitator works for the organizational person and is essential to help them carry out their goals.

Some time ago in clinical art psychotherapy, a group led by two clinicians was regularly supervised by a senior clinician. Dual supervision was viewed as a necessity in order to express and resolve the sometimes conflictual interactions and feelings between the two group leaders so that the group could move forward under a single helm and not get sidetracked into internecine battles. Unfortunately, due to constraints of time and money, group leaders are typically not supervised in this manner today and as a result, many groups exhibit unresolved leadership issues. It would be wise for the novice Graphic Facilitator to have the experience of working with an organizational facilitator or two and discuss the interaction with their mentor. In this manner, they will develop skills to create an effective dyad.

While the Graphic Facilitator, in some ways, acts as an independent person and is certainly viewed as the "art expert," he or she is *employed as a consultant by the organization* and is present to accomplish specific documentation tasks. Within this well-delineated role, the Graphic Facilitator, through the process of interpretation, conveys a certain air of artistic freedom, but to veer off in a manner oppositional to another facilitator is both hazardous and useless to the goals of the organization. The two facilitators must function together as a team as best they can. Usually it will be the Graphic Facilitator who will need to press for discussion time before the event with the other facilitator to enhance the team approach. The other facilitator may not value or understand the "artist's" role, and may even want to minimize it. (This is usually not a result of bad intentions, but almost always is due to lack of exposure to a Graphic Facilitator and what she or he does with organizations.)

The Graphic Facilitator's meeting with the organizational facilitator must create an understanding and clear definition of the scope and goals of the two facilitators' tasks. The contract is set during this meeting, as well as a time established for processing of the experience

together after the event. Often the client and/or co-facilitator aren't aware to leave time for processing after the experience and may not have much of a sense that this is essential; it is the Graphic Facilitator's responsibility to prepare his or her co-worker for the processing afterward and make sure it happens.

Key Skill 6: Media

It is the Graphic Facilitator's responsibility to provide the media to document the organization's events or dialogues. Two-dimensional media that can be easily carried, relatively simple to use, and easy for participants to see across a large room, are ideal. For example, a pencil and pen would not be good media to use because the marks made from these instruments are often difficult to see at any distance. There is a good deal of choice in media, but *it should include color*–large marking pens and chalk pastels are good for this. A suggested list of media is:

1. Paper for the documenting mural.
 The paper should be sturdy–a better quality than newsprint–but it should not be of such good quality that it would intimidate the Graphic Facilitator or the group participants. It is important that it have a life span not only when created by the Graphic Facilitator but also afterward when it can be potentially used by the organization. 48-inch width works well. Paper for the mural should be hung on the wall in advance of the arrival of participants and should allow for extensions if the Graphic Facilitator makes such a decision.
2. Artist's tape.
 For hanging paper on the wall. Artist's tape is white, acid free with a neutral ph. Most importantly, it is repositionable on walls and doesn't take paint off. It can be bought at art supply stores or on the web.
3. Large markers of a variety of colors (with varying thicknesses).
 If the Graphic Facilitator is concerned that the markers will "bleed" through to the wall, a double layer of paper can be used. Odor-free markers are preferable because some participants are sensitive to the smells.

4. Large chalk pastels of a variety of colors.
 Note: It is imperative that the Graphic Facilitator be able to rapidly cover space with color. Do not use oil pastels.
5. Spray Fixative to fix chalk at the end of the project.
6. Apron to protect your clothes.
7. Sketchbook.
8. Post-its in a variety of sizes and colors.

Key Skill 7: Appreciation for and Understanding of Groups and Organizations

Much business and organizational work is done in groups, if for nothing else, than a group is usually cost and time effective and helps develop the interactional team. Graphic Facilitation, as here defined, has its origins and current practice in organizational development and in group psychotherapy.

Organizational Development

Norbert Weiner's ideas during World War II contributed in important ways to artillery feedback mechanisms and they greatly improved accuracy. After the war, Weiner generalized his concepts of "Cybernetics" (Greek for "the science of steermanship"). His ideas created great intellectual excitement and helped to change many engineering and science professions.

Kurt Lewin (1898–1947)[3] is generally recognized as the father of organizational development. Intrigued by Weiner's notions, Lewin applied them to human interactions and thus brought them into personal and workplace spheres. He described the nature and qualities of interpersonal feedback and his ideas of group dynamics and Action Research[4] underpin basic organization development process as well as providing its collaborative consultant/client thrust.

Lewin founded the Research Center for Group Dynamics at MIT which was moved to the University of Michigan after his death. Some of his colleagues were among those who established the National Training Labs (NTL) which originated the T (Training) Group. Thus

3. Information about Kurt Lewin comes from en.wikipedia.org/wiki/organization development.
4. Action Research generally entails three steps: (1) planning, (2) taking action, (3) measuring the results of the action.

group-based organizational development evolved. This concept proposes that the basic building blocks of an organization are groups (or teams) and that groups, not individuals are the basic units of change. The field of Applied Behavioral Science using groups intends to implement positive change in an organization. Applied Behavioral Science is interdisciplinary in nature drawing on psychology, sociology, and theories of motivation, learning, and personality.[5] NTL today is based in Arlington, Virginia.

During this time, the Tavistock Institute of Human Relations in Great Britain was important in developing systems theories. Douglas McGregor and Richard Beckhard in the 1950s, "consulting together at General Mills in the United States coined the term 'organizational development' to describe an innovative bottoms-up change effort that fit no traditional consulting categories" (Weisbord, 1987, p. 112).

Art Therapy Groups

Art therapy in group settings is a long-standing combination. But there has been great variety in the nature of the group. Today, it is usually a group with a particular population, specific diagnosis or problem area that is called for and which an art therapist may be invited to form. All too often, assumptions about group art therapy are that art is a uniquely inviting *technique* for clients or patients that can be included as a kind of innovation. Often artists are asked to paint with psychiatric patients because of the basic notion that painting by dysfunctional people is always good. Not always understood, unfortunately, are the depths, potentialities, and sometimes dangers of artmaking in a group setting or indeed, with an individual.

Originally, more like an art class, art was an "activity therapy" in a psychiatric hospital or social setting. It occurred in a studio-like room in which patients worked individually and focused on their own creative process. The interpersonal nature of this form of art activity happened as a side effect, if it happened at all. The current Open Studio movement in art therapy has its roots here.

During and after World War II, group therapy emerged to treat the great numbers of military personnel with problems and, chronologically, it parallels the history of the development of the art therapy pro-

5. www.referencefor business.com)A-bud.

fession. In the 1970s, growth groups proliferated, including "encounter" and those at the Esalen Institute in Big Sur, California. These groups were shaped and influenced by Kurt Lewin's ideas and the work at Tavistock in England.

The group therapy model in which the *group, not the individual,* is the agent of change has been defined by Waller (2003) as "interactive" or "interpersonal." Based first in group analysis and psychotherapy (e.g., Foulkes, 1948; Yalom, 1985), the interpersonal theory of Harry Stack Sullivan[6] is central to this approach. Waller (2003) states that art making can enhance the dynamics of an interactional group.[7] There is a good deal of literature on art making and imagery in group settings. Barron (1989), Acterberg (1986), Dreifuss-Kattan (1990), Malchiodi (1997, 1998, 1999), and Riley (2000) are examples. In particular, the reader is referred to Malchiodi (2003), *The Handbook of Art Therapy,* Part V, "Clinical Applications with Groups, Families and Couples" for a good explanation of art therapy in a wide variety of groups with different goals and intentions.

Key Skill 8: Learning Organizational Language

As it is important for the clinical art therapist to learn to speak the particular language of her or his clients, so it is essential that the Graphic Facilitator consultant speak the language of business and organizations he or she works with. For example, a client language may be gender or profession based. It may feel as foreign as if it were from another country. There are commonly used words in business and organizations such as "strategy," "needs assessment," and "human resources" which may not be familiar to the novice Graphic Facilitator. Learning the language and its meaning to the client population is a necessary key skill. In addition, the Graphic Facilitator should know the meaning of particular acronyms used by the organization before the event. Flubbing or confusing acronyms, or misspelling them, will not be helpful to the process.

6. Much social work education and practice is strongly influenced by Sullivan's theories.
7. The reader is referred to Malchiodi, C. (Ed.) 2003, *Handbook of Art Therapy,* Part V. Clinical Applications with Groups, Families and Couples, which provides about 50 pages of good material on art therapy groups.

Key Skill 9: Development of the Graphic Facilitator's Background

Organizational consulting using art is an exciting new arena for the art therapist. But it is not necessarily a simple task to gain the skills necessary to function well in this milieu. The art therapist planning to become an organizational consultant will need to acquire a background in organizational development and theory. It should not be assumed that art therapy education trains one to take on business clients. Much more is needed. That the organization or group has a psychology to it is a necessary base consideration and that the art therapist/consultant should have an understanding of that psychology in moving forward is a first priority.

However, the organizational consultant's approach needs to be quite different from that of the mental health clinician. Organization development is a field in and of itself, with its own language, ethics, and practices. The art therapist will need to become familiar enough with the field as a whole to know her or his way around and to speak the language of the organization. Many skills already acquired by the art therapist will be useful in organization and group work, but the language of healing so familiar to therapists is not appropriate for organizational consulting work.

There are many roads the art therapist can travel to find his or her way to comfort in organizational settings. A number of basic organizational readings are listed in the Bibliography of this book. Another book essential to the consultant is Lippitt and Lippitt's *The Consulting Process in Action* (1986). For a complicated, provocative, and important book about systems change and organizations, McWhinney's (1987) *Paths of Change, Strategic Choices for Organizations and Society,* along with its companion book, *Creating Paths of Change, Revitalization, Renaissance & Work,* are highly recommended (McWhinney, McCulley, Webber, Smith & Novokowsky, 1993).[8]

For more formal classroom education, we suggest that the art therapist engage in university-level courses in business, management, and

8. Junge's *Creative Realities, the Search for Meanings* is an application of McWhinney's model to creative thinking and action.

management consulting.[9] It is also recommended that the art therapist become a member of Organizational Network or another organizational professional organization and attend some of its yearly conferences. The art therapist becoming an organizational consultant will need to know enough about this new field to get along. Furthermore, it will be highly advantageous to make contacts and develop a lively and friendly network of OD connections which may lead to important referrals in the future.

FINDING A MENTOR

The fledgling Graphic Facilitator will need a mentor/supervisor to help with every phase of the work from setting the Letter of Agreement/contract on. Such a mentor is not easy to find. An art therapy professional's experience in group psychotherapy is not sufficient and may lead into erroneous methods and pathways, because the Graphic Facilitator *is not doing art psychotherapy.*

The mentor should have the key skills listed in the previous section along with art therapy skills. In addition, she or he should have experience in art making with groups, organizations, and knowledge of the organizational development and business fields. Although regular, in-person contact is best, the telephone and the computer are important tools in that geographic proximity is often impossible between mentor and mentee. It is essential that the mentor be a competent and experienced professional with knowledge of organizational development and art therapy.

A new Graphic Facilitator may wish to contact a few potential mentors to select the one he or she wants to work with. The mentor should be directly approached to see if she or he is available for the task. Then, it is suggested that the mentee have a 45-minute to an hour's telephone discussion with each possible mentor in which expectations, theoretical orientations and ideas, organizational experience,

9. Note: Education and readings in what they used to call "Personnel" (now generally called "Human Resources") are too limited and we do not consider it appropriate for a Graphic Facilitator. In order to become a Graphic Facilitator, the art therapist needs to grow familiar and comfortable with the profession of Organizational Development, its boundaries, goals, and potentials as well as its particular language.

and financial arrangements can be explored by both the mentor and the mentee. If it is the case, the mentee should tell the senior person that will be talking to a number of potential mentors, and that he or she will make a selection soon. (It is professional courtesy to tell the mentors not chosen of that fact as well as the one the trainee decides to work with.)

During the training period, if at all possible, the new Graphic Facilitator should act as an assistant to the senior person, sitting in and observing how she or he works without having the pressure of creating the mural. Tasks can be assigned by the senior Graphic Facilitator, but it will be important for the mentee to be free enough of formal responsibilities to be a careful observer of group dynamics and the verbal and nonverbal role played by the mentor. The mentee should write up the organization experience using a format provided by the mentor and including the artwork, its meaning, interpretations and important interventions. By rethinking the experience in this way, the trainee can gain an extended understanding of the Graphic Facilitator's role and interaction with the group.[10] (Appendix B provides a suggested format for a Graphic Facilitation Write-Up.)

Less than ideal, but possible, is the mentor who is an experienced organizational person not knowledgeable about art but open to the Graphic Facilitation process and willing to mentor the new Graphic Facilitator. They should have an understanding of the psychology of organizations and be well-versed in the vicissitudes and language of business life. (Social psychologists are often particularly good at this.) While organizational development mentors may not have a rich art experience nor understand art interventions at a basic level, they are often open to and excited about the potentials of art. It is important that the trainee not simply work verbally with the mentor. She or he must show the mentor the artwork and include it in the supervisory or coaching session. (Inclusion of the artwork educates the mentor and helps him or her understand the deeper potentials of art with organizations.)

10. The model of the trainee first being an observer of the process and then accomplishing a write-up of the session is one often used to train art therapists.

In our experience, a number of organizational people are quite interested in art or are even artists themselves.[11] Teachers in university departments and facilitators at National Training Labs (NTL), who are often independent consultants to business through the professional group "Organizational Network," are good resources and may provide useful referrals to a mentor.

How long do I need a mentor? In the past and even presently, there have been many informal mentoring relationships not called by that name; teacher/student is an example. In the present day, mentoring relationships tend to be more overt with both participants having a mutual understanding of the undertaking; there is also the probable necessity of paying a fee to the mentor for service.

A dictionary definition of a mentor is "a trusted counselor or guide."[12] While the Graphic Facilitator is a beginner, an active, close, and regular involvement with the mentor is necessary. As the Graphic Facilitator becomes more experienced, the involvement may be less. All in all, becoming a mentor and a mentee is a long-term proposition–perhaps of many years. A mentor is necessary for even an experienced art therapist because it should not be assumed that therapy skills are easily transferable into the organizational arena. From a good mentor, the mentee has the opportunity to gain both explicit and implicit skills. And perhaps most importantly, the relationship provides essential support and information from a senior person in the field. It is a crucial relationship and the crucible in which a Graphic Facilitator can be born, develop, and flourish.

HOW DO I GET WORK?

If you are good at what you do, your business will grow through word of mouth over time. In the beginning, however, it is recommended that you volunteer with as many different types of organizations as possible. The only way to really learn this craft is under fire, on the job. Ideally, you will first volunteer under a mentor who has

11. M.B.J.: During my doctoral work at Fielding University in Human and Organizational Systems, the faculty exhibited more interest in and appreciation of art than I had ever encountered in more direct art programs taught by artists, including at the MFA level.

12. *Webster's Ninth New Collegiate Dictionary* (1986). Springfield, MA: Merriam-Webster Inc., Publishers.

experience artistically as a Graphic Facilitator with organizations, and who understands systems and how organizations operate. It may be difficult to find such a senior person as, so far, there aren't a lot of Graphic Facilitators in North America. But it is well worth the trouble and will greatly enhance the development of abilities and comfort of the fledgling Graphic Facilitator for the future.

After you have had some exposure, you can volunteer on your own. It is important to convey to clients what you are offering in terms of your experience level, because they could be a paying customer in the future, and it is important to establish a good rapport as soon as possible. Remember: organizations are varied and everywhere. Anyone may turn into a client.

Graphic Facilitation involves some performance pressure and is not suited for everyone. For example, it does not have the same kind of quiet intimacy behind closed doors that an individual or family art therapy session can have. It is much more a *public event*. It demands a performance, speed, and excitement, along with the potential to encourage organizational change that many of us thrive on. This is another benefit to volunteering, to determine if this approach is the right fit for you professionally.

After you have some comfort with the process, you will begin setting low fee prices appropriate for your level of skill. Over time, you can raise your fees as you build your business. If you deliver good, creative work that is meaningful to the client, you will be asked back, and recommended to other clients. You are marketing and selling a product (graphic images, murals) and a process (organization development). Having skills in both is critical to your success in this field.

Chapter X

CONCLUSIONS

In this book, we suggest a new and exciting avenue for art therapists and for organizational development consultants using Graphic Facilitation. We have presented a detailed explanation of Graphic Facilitation–what it is and why and how it works, ideas about how to become trained as a Graphic Facilitator, a multidisciplinary literature base and resources that will be needed. The book's References and Bibliography include pertinent, classic organizational development literature, essential learning for work in the area. In the rear of the book is a CD-ROM containing the book figures *in color* and a short film "Graphic Facilitation in Action" in which co-author Michelle Winkel can be seen creating a mural during an organizational meeting.

Five case studies are described which carefully lay out the Graphic Facilitation process and include visual murals and other imagery created by the Graphic Facilitator throughout the process of each organizational event. The case studies clearly illustrate the value and promise of art therapy as an exciting new tool and provide a view of the impressive use of Graphic Facilitation with a wide variety of organizational style, models, and issues.

While some art therapists have sporadically done this kind of work, forays by art therapists into the organization arena have been virtually nonexistent. What is currently published and presented at conferences by art therapists has little relevance to Graphic Facilitation. In the related fields of visual practice, some practitioners have been quick to recognize the immense potential of combining the visual with words, but most come from the corridors of business and do not understand the depths and complexities of the psychologies or organizations, nor the inherent aesthetic opportunities. Typically, they do not have training as artists nor as art therapists.

The immense interest in this new bridge of words and imagery is evidenced by the explosion of online dialogue about the use, not only of words, but of images to describe what's important to us, how we make sense and meaning of information, and together, solve our problems.

But there are hazards here too—on both sides. Poorly trained organizational consultants who use visuals might only draw the words they hear, often missing the gold that the art therapist is taught to dig for. Dr. Charles Seashore, in his Foreword to this book, says, "[words are] often our best defended tools of disclosure." The art therapist who has experienced and relies on the typical individually-based training may have a tough time understanding and portraying the "whole" of the group's concerns. Although a typical art therapy education includes some group work, it is the rare art therapist who is able to understand and embrace a systems perspective. Historically and culturally, ideas about thinking and clinical assessment are typically linear and cause and effect. We suspect it will take some time and effort for most art therapists to grasp a different approach than they are used to. However, it will be well worth the effort.

An art therapy client creates a piece of art to explore conscious and unconscious dynamics within. The created image communicates unconscious needs and brings unknown unconscious and secret processes into the light in a new, less terrifying or habitual format. The Graphic Facilitator as an active choice-maker represents the *group's* words and dynamics through visual metaphor. The mural provides a *visual place, in real time,* for renewed reflection and new and deeper insights. Experiencing their projected process in color and three-dimensional drawings, often enables the group to move forward.

The fields of organizational development and human resources coaching have long proposed that it is the complex human interactions and the ability of people to adapt and work together that either hinder an organization or enable it to soar beyond its competitors. Like art therapists, Graphic Facilitators provide reflection and guidance for the work to be truly seen and meaning understood in a concrete visual fashion—an important step toward implementing creative innovation and change.

APPENDICES

Appendix A

SAMPLE LETTER OF AGREEMENT/CONTRACT

Should be on your letterhead insert your contact information here

Name of Organization/Company
Address
City, State
Country
Zip Code

Current date

Dear (Insert name of client)

Let this serve as a Letter of Agreement between (insert name of organization/company) and (your name as Graphic Facilitator Consultant) regarding Graphic Facilitation services and documentation effective (insert current date) until completion of the project. The following is understood:

SERVICES

Consultant shall provide:
1. Graphic Facilitation on (date of event/s)
2. Art materials
3. Digital images on-site of mural/s–although quality cannot be assured. (Professional photographs of murals can be arranged by Consultant. Billing will be based on rates quoted by the photographer.)

Client shall provide:
1. Hotel and travel expenses (to be negotiated)
(Sample Letter, Page 2)

2. Assistance with organizing adequate wall space
 (Occasionally a suitable white board may need to be rented. The company will be billed for this if it is needed.)

FEES

1. Consultant will bill organization $$ (<u>insert your fee</u>) plus travel and hotel expenses. Total will not exceed $$ (<u>negotiate this</u>).
2. Consultant will submit an invoice at the completion of the project with payment by organization within 30 days of billing.
3. If organization would like changes or additions to the murals following the event, consultant will negotiate a fee per hour.

CONFIDENTIALITY

1. Murals and artwork become the property of the organization upon completion of the event.
2. Consultant reserves the right to use images from the murals for promotional and educational purposes with permission of organization and with the promise of confidentiality and removal of identifying information, if desired by the organization.
3. Special additional permission from the organization will be obtained by the consultant if they plan to use artwork in a journal article, conference presentation or book.

CONSULTANT AS INDEPENDENT CONTRACTOR

It is understood that CONSULTANT is and provides the services of an **independent contractor**. Therefore, they are responsible for any appropriate taxes arising from payment of fees. This agreement in no way implies an employer-employee relationship.

_____ _____
Client's Signature Date

_____ _____
Consultant's Signature Date

Appendix B

SAMPLE WRITE-UP AND CONVERSATION GUIDE GRAPHIC FACILITATOR/ CONSULTANT-SUPERVISOR

(To be filled out by the Graphic Facilitator
for session with consultant/supervisor.)

Graphic Facilitator's Name_____

Consultant/Supervisor's Name _____

Client's Name_____

Date_____

Nature of Event _____

Preparation:
Describe your preparation for the event. Describe all preparatory meetings with Client. State date of meeting, who was there, what was discussed and what conclusions or agreements were reached. Note specific unfinished issues. If there is an agenda for The Event, attach it to this write-up.

Your thoughts, ideas, and guesses about major organizational issues. Why Graphic Facilitation will enhance the meeting?

(Page 2, Sample Write-Up and Conversation Guide)

Make a systems statement as you see it about the organizational issues.

Event:

1. Describe the number of participants, job titles, layout of group in the room (Circle? Lines? Who sits with whom?)

2. What is the group's emotional tone at beginning of meeting (Friendly? Reserved? Enthusiastic? Reluctant? etc.)

3. Describe your physical position in relationship to the group (where did you stand, sit etc.?). Describe the participants' initial emotional reactions to you. (If there are individual differences, state them.)

(Page 3, Sample Write-Up and Conversation Guide)

4. Describe your observations of the (other) facilitator's style. How did he or she interact with the group? How effective did he or she appear to be? How did you two do together?

5. Artwork:

Attach a copy of the artwork/murals for discussion. Describe your process, stating what metaphors were chosen and why. What was effective about your work? How was it effective? What was *not* effective and why?

 a. How do you believe the artwork affected the course, flow, and outcome of the meeting?

 b. Consider your metaphors once again. Did the group generate the metaphor/s or did you? Why were they useful? Why were they not? What metaphors might have been added? What metaphors might have been more useful.

(Page 4, Sample Write-Up and Conversation Guide)

State specific positive and negative outcomes of the Event:

 1.

 2.

 3.

 4.

 etc.

On a scale of 1–10, with 10 being the best and 1 being the worst, rate your performance as a Graphic Facilitator. State why you chose this rating.

Follow up?

Additional comments, observations, or questions.

Appendix C

RESOURCES

Professional Organizations

American Art Therapy Association: www.arttherapy.org

Canadian Art Therapy Association: www.catainfo.ca

International Art Therapy Association:
www.internationalarttherapy.org/ (Totally on-line and free)

International Expressive Arts Therapy Association: www.ieata.org/

Organizational Development Network (ODNet): www.odnetwork.org/

National Training Labs (NTL): www.ntl.org/

Visual Practitioner Resources, Forums, and Blogs

International Forum for Visual Practitioners (IFVP): www.IFVP.org

RSA Animate (Think tank based in England): www.Thersa.org

The Grove Consultants International: www.Grove.com

DigitalRoam: www.digitalroam.com

VizThink: www.vizthink.com

REFERENCES AND BIBLIOGRAPHY

*Argyris, C., & Schon, D. (1978). *Organizational learning: A theory of action research.* Reading, MA: Addison-Wesley[1]

Arnheim, R. (1969a). *Visual thinking.* Berkeley, CA: University of California Press.

Arnheim, R. (1969b). *Art and visual perception.* Berkeley: University of California Press.

Ault, R. (1983). Art therapy and the business world–Exploratory studies. Paper presented at the 14th American Art Therapy Association conference, Chicago, IL.

Ault, R. (1986, September). Draw on new lines of communication. *Personnel Journal,* 72–77.

Ault, R., Barlow, G., Junge, M., & Moon, B. (1988). Social applications of the arts. *Art Therapy, Journal of the American Art Therapy Association, 5,* 10–21.

*Beckhard, R. (1969). *Organizational development. Strategies and models.* Reading, MA: Addison-Wesley.

Berger, J. (1972). *Ways of seeing.* Great Britain: BBC and Penguin Books.

Bosky, J. (1992). *Creative organizational consultation by an art therapist.* Unpublished Master's Thesis. Loyola Marymount University, Los Angeles, CA.

Buzan, T. (1996). *The mind map book: How to use radiant thinking to maximize your brain's untapped potential.* New York: Plume.

Cooperrider, D. (1986). *Appreciative inquiry. Toward a methodology for understanding and enhancing organizational innovation.* Unpublished Ph.D. dissertation, Case Western Reserve University, Cleveland, OH.

Cooperrider, D., & Srivastva, S. (1987). Appreciative Inquiry in organization life. In W. Rasmore & R. Woodman (Eds.), *Research in organization change and development* (Vol. 1) (pp. 129–169). Greenwich, CT: JAI Press.

Feen-Calligan, H. (2008). Remembering Robert E. Ault (1936–2008). *Art Therapy, Journal of the American Art Therapy Association, 25,* 85–89.

1. All books with asterisks (*) are recommended for organization development background.

Gebser, J. (1985). *The ever-present origin.* Noel Barstad (Trans.) Athens, Ohio: University of Ohio Press. (Originally published in German 1949–53).

Gonick, L., & Smith, W. (1993). *Cartoon guides to statistics.* New York: Harper Collins.

Grinder, J., & Bandler, R. (1981). *Trance-formations: Neurolinguistic Programming and the structure of hypnosis.* Boulder, CO: Real People Press.

Greenson, R. (1967). *The technique and practice of psychoanalysis.* New York: International Universities Press.

Haley, J. (1973). *Uncommon therapy. The psychiatric techniques of Milton H. Erickson, MD.* New York: W.W. Norton.

Hammond, S. (1996). *The thin book of Appreciative Inquiry.* Plano, TX: Thin Book.

Helgesen, S. (1990). *The female advantage: Women's ways of leadership.* New York: Doubleday/Currency.

Herge (Georges Remi) (1930). *The adventures of Tintin. Tintin in the land of the soviets.* New York: Little Brown Books for Young Readers.

Herge (Georges Remi) (1986). *Tintin and Alph-art.* New York: Little Brown Books for Young Readers. (Unfinished work, published posthumously).

Holmes, N., Reiter, M., & Sandomir, R. (2007). *The enlightened bracketologist: The final four of everything.* London: Bloomsbury.

Horn, R. (1999). *Visual language: Global communication for the 21st century.* Bainbridge Island, WA: MacroVU, Inc.

Junge, M. (1998). *Creative realities, the search for meanings.* Lanham, MD & Oxford: University Press of America.

Junge, M., (2010). *The modern history of art therapy in the United States.* Springfield, IL: Charles C Thomas.

Junge, M., & Wadeson, H. (Eds.) (2006). *Architects of art therapy, memoirs and life stories.* Springfield, IL: Charles C Thomas.

Kearney, L. (1996). *Graphics for presenters–Getting your ideas across.* Menlo Park, CA: Crisp.

Kramer, E. (1971). *Art as therapy with children.* New York: Schocken.

**Kuhn, T., (1964). Structure of scientific revolutions. Chicago, IL: University of Chicago Press.

Lakoff, G., & Johnson, M. (1980). *Metaphors we live by.* Chicago, IL: University of of Chicago Press.

Langs, R. (1982). *Psychotherapy, a basic text.* New York: Jason Aronson.

*Lewin, K. (1958). *Group decision and social change.* New York: Holt, Rinehart & Winston.

*Recommended for organization development background.
**Kuhn's book revolutionized thinking in the sciences and social sciences. We believe it should be read by all those interested in Graphic Facilitation.

*Lippitt, G., & Lippitt, R., (1986). *The consulting process in action.* San Diego, CA: University Associates.

Maal, N., Wheatley, M., & Margulies, N. (2001). *Mapping inner space* (2nd ed.). Thousand Oaks, CA: Sage/Corwin Press.

Margulies, N. (1991). *Yes, you can draw!* Tucson, AZ: Zephyr Press.

Margulies, N. (1993). *Maps, mindscapes and more* [VHS]. Tucson, AZ: Zephyr Press.

Margulies, N. (1995). *Map it! Tools for charting the vast territories of your mind* [comic book]. Tucson, AZ: Zephyr Press.

Margulies, N. (2005). *Visual thinking: Tools for mapping your ideas.* Thousand Oaks, CA: Sage/Crown Press.

Margulies, N., & Gelb, M. (1989). *The mind map.* Washington, DC: High Performance Learning.

Margulies, N., & Maal, N. (2001). *Mapping inner space: Learning and teaching visual mapping.* Thousand Oaks, CA: Sage/Corwin Press.

Margulies, N., & Valenza, C. (2005). *Visual thinking: Tools for mapping your ideas.* Norwalk, CT: Crown.

McGinn, D., & Crowley, S. (2010, September). Vision statement: Tired of PowerPoint? Try this instead. *Harvard Business Review,* Boston: Harvard Business School Publishing.

*McWhinney, W. (1997). *Paths of change, strategic choices for organizations and society* (Rev. ed.). Thousand Oaks, CA: Sage.

*McWhinney, W., McCulley, E., Webber, J., Smith, D., & Novokowsky, B. (1993). *Creating paths of change, revitalization, renaissance & work.* Venice, CA: Enthusion, Inc.

Mitchell, W. (1986). *Iconology: Image, text, ideology.* Chicago & London: University of Chicago Press.

Mitchell, W. (1995). *Picture theory: Essays on verbal and visual representation.* Chicago & London. University of Chicago Press.

*Morgan, G. (1998). *Images of organization.* San Francisco: Berrett-Koehler.

Naumburg, M. (1966). *Dynamically oriented art therapy: Its principles and practice.* New York: Grune & Stratton.

O'Hanlon, W. (1993). *An uncommon casebook: The complete clinical work of Milton H. Erickson.* New York: W. W. Norton.

Pink, D. (2005). *A whole new mind: Why right-brainers will rule the future.* New York: Penguin Group.

Riley, S., & Malchiodi, C. (2003). Family art therapy. In C. Malchiodi (Ed.), *Handbook of art therapy.* New York: The Guildford Press.

*Recommended for organization development background.

Roam, D. (2008). *The back of the napkin: Solving problems and selling ideas.* New York: Penguin Group.

Roam, D. (2009). *Unfolding the napkin: The hands-on method for solving complex problems with simple pictures.* New York: Penguin Group.

Royal, C., & Hammond, S. (Eds.), (2001). *Lessons from the field.* Plano, TX: Thin Book.

*Seashore, C., Seashore, E., & Weinberg, G. (1991). *What did you say? The art of giving and receiving feedback.* North Attieborough, MA: Douglas Charles Press.

*Senge, P. (1990). *The fifth discipline.* New York: Doubleday/Currency.

Sibbet, D. (1991). *Fundamentals of graphic language: Graphic guides.* San Francisco, CA: Grove Consultants International.

Sibbet, D. (1994). *Pocket pics.* San Francisco, CA: Grove Consultants International.

Sibbet, D. (2002). *Best practices for facilitation.* San Francisco, CA: Grove Consultants International.

Sibbet, D. (2010). *Visual meetings: How graphics, sticky notes and idea mapping can transform group productivity.* Hoboken, NJ: John Wiley & Sons.

Sonneman, M. (1997). *Beyond words: A guide to drawing out ideas.* Berkeley, CA: Ten Speed Press.

Srivastva, S., & Cooperrider, D. (1986). *The emergence of the egalitarian organization.* Human Relations, London: Tavistock.

Stoll, B. (1998). An art therapist responds to disaster. *Southern California Art Therapy Association Newsletter, 8,* 1.

Stoll, B. (1999a). Taking art therapy into the workplace. Paper presented at the 30th American Art Therapy Conference, Orlando, FL.

Stoll, B. (1999b). When disaster calls, an art therapist responds. *American Art Therapy Association Newsletter, XXXII,* No. 2.

Tufte, E. (1983). *The visual display of quantitative information.* Cheshire: CT: Graphics Press.

Tufte, E. (1990). *Envisioning information.* Cheshire, CT: Graphics Press.

Tufte, E. (1997). *Visual explanations: Images and quantities, evidence and narrative.* Cheshire, CT: Graphics Press.

Tufte, E. (2003a). PowerPoint is evil. In *Wired, 11,* 9.

Tutfe, E. (2003b). *The cognitive style of PowerPoint.* Cheshire, CT: Graphics Press.

Tufte, E. (2006). *Beautiful evidence.* Cheshire CT: Graphics Press.

*Recommended for organization development background.

Turner, Y., & Clark-Schock, K. (1990) Dynamic corporate training for women: A creative arts therapies approach. *The Arts in Psychotherapy, 17,* 217–222.

Waller, D. (2003). In C. Malchiodi (Ed.), *Handbook of art therapy.* New York: Guildford Press.

Watkins, J., & Mohr, B. (2001). *Appreciative Inquiry: Change at the speed of imagination.* San Francisco, CA: Pfeiffer.

Wescott, J., & Landau, J. (1997). *A picture's worth 1,000 words. A workbook for visual communications.* San Francisco, CA: Bass/Peiffer.

*Weisbord, M. (1987). *Productive workplace: Organizing and managing for dignity, meaning and community.* San Francisco, CA: Jossey-Bass.

www.Theworldcafe.com/retrieved June 15, 2011.

Witzum, E., Van der Hart, O., & Friedman, B. (1988). The use of metaphor in psychotherapy. *Journal of Contemporary Psychotherapy.*

Yaffa, J. (2011). The information sage, *Washington Monthly,* May/June, http://www.washingtonmonthly.com/magazine/mayjune_2011/features/the_information_sage029137.Php?page+all, retrieved June 25, 2011.

*Recommended for organization development background.

ABOUT THE AUTHORS

Michelle Winkel, MA, MFT, ATR

Beginning in architecture, Michelle Winkel has been committed to visual expression and thinking throughout her career. She received a Master's Degree in Marriage and Family Therapy/Clinical Art Therapy from Loyola Marymount University, Los Angeles in 1995 and was awarded a fellowship in Infant-Parent Mental Health from Harvard Children's Hospital for 2004–2005. She practiced art therapy in Los Angeles, Sacramento, and British Columbia and was a staff member at Brotman Medical Center, Los Angeles Gay and Lesbian Center, and Placer County Office of Education where she also consulted to the Placer County Families First coalition. Her teaching experience includes Group Dynamics at Loyola Marymount University, and more recently at the British Columbia School of Art Therapy, where she was also the Executive Director. Since 1999, Michelle has used art therapy and Graphic Facilitation with businesses and organizations. In these consultations, she incorporates her training and her skills as an artist and art therapist. This is her first book. Her email address is Michelle@unfoldingsolutions.com.

Maxine Borowsky Junge, Ph.D., LCSW, ATR-BC, HLM

Maxine Borowsky Junge has been an art therapist for more than 40 years. This book is her sixth. Her last book was *The Modern History of Art Therapy in the United States*, the only history in book form of the innovative and fascinating profession of art therapy. During her long career, Dr. Junge taught at Immaculate Heart College, Goddard College, Antioch University–Seattle and at Loyola Marymount University for more than 20 years, where she was also Director of the Marital and Family/Clinical Art Therapy Program. She practiced clinical art therapy at Cedars-Sinai Hospital, Ross-Loos Department of Psychiatry, Council of Jewish Women, the AIDS Clinic of Dr. Michael Scolaro and in private practice–all in Los Angeles. She formally studied organizational development and received her Ph.D. in Human and Organizational Systems from Fielding Graduate University in 1992. Since then she has maintained an organizational consulting practice. In 2001, Dr. Junge moved to Whidbey Island, in the Pacific Northwest where she writes, paints, and consults with local clinicians. On Whidbey, she worked for a number of years with Compass Health. In 2012, Dr. Junge received

the Distinguished Alumna Award from Scripps College, Claremont, CA for her contributions to art therapy. Her email address is Mbjunge@whidbey.net. (Photo by Benjamin Junge.)

ABOUT THE CD-ROM

This CD contains the following material that supplements the text.

Color Figures: *(jpeg format)*

> Figure I-1. Growth From the Roots Up
> Figure III-1. Elephant in the Room -Opportunities
> Figure III-2. Connecting and the Difficulties to Connecting
> Figure IV-1. The Starting Line
> Figure IV-2. Ideal Service Delivery Path
> Figure V-1. Building Bridges (left)
> Figure V-1. Building Bridges (right)
> Figure V-2. Sabiduria Colectiva Fortaleza Comunitaria (Collective Wisdon Community Strength)-Logo
> Figure V-3. Birthing New Ideas
> Figure VI-1. Performance Accountability
> Figure VI-2. Community Empowerment Through Data Gathering
> Figure VII-1. Borders and Timeline
> Figure VII-2. Timeline Draft
> Figure VII-3. Process Gaps
> Figure VII-4. Twin Towers Burning

Short Film: *(wmv format)*

> Graphic Facilitation in Action